THE BRANCH LINES OF
WORCESTERSHIRE

THE BRANCH LINES OF
WORCESTERSHIRE

COLIN G. MAGGS

AMBERLEY

Front cover: Semaphore signals on the Severn Valley Railway, Bewdley, 21 October 1976. *Revd Alan Newman*

Back cover: Ivatt Class 4MT 2-6-0 No. 43106 at Bewdley, 21 October 1976. *Revd Alan Newman*

First published 2010

Amberley Publishing
Cirencester Road, Chalford,
Stroud, Gloucestershire, GL6 8PE

www.amberleybooks.com

British Library Cataloguing in Publication Data.
A catalogue record for this book is available from the British Library.

ISBN 978-1-84868-344-0

Typesetting and Origination by Amberley Publishing.
Printed in Great Britain.

Contents

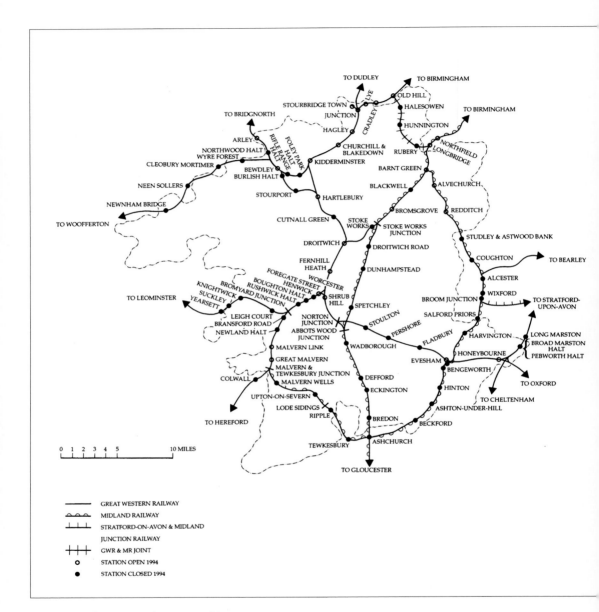

Railway map of Worcestershire.

Introduction

The basic pattern of railways in Worcestershire was relatively simple. The Oxford, Worcester and Wolverhampton, known from its initials as the 'Old Worse & Worse', ran east to west across the southern half of Worcestershire and then turned north to bisect the county. Opened in 1853, the OWWR used some of its own standard gauge stock and hired the remainder from the London and North Western Railway. In 1860 the OWWR became part of the West Midland Railway and three years later was absorbed by the GWR.

The Midland Railway's main line ran through the county north to south approximately parallel with that of the OWWR. Although the MR owned a direct line between Stoke Works Junction and Abbots Wood Junction, quite a number of its trains used running powers over part of the OWWR to travel via Worcester. The MR also had a line from Barnt Green through Redditch, Alcester and Evesham to Ashchurch, which could be used as an alternative route to the main line as weight restrictions did not preclude the use of quite large engines.

Today the only former GWR branches which remain in use by the national railways are those from Honeybourne to Long Marston, and Stourbridge Junction to Stourbridge Town, but the Severn Valley Railway flourishes in private hands. Although for most of its life the line from Droitwich to Lye and Birmingham was a main line, in recent years it has been relegated to secondary status and may be considered a branch. The only ex-Midland Railway branch still open is that from Barnt Green to Redditch, and with electrification in 1993 – the first in the county – its long-term future should be assured.

In order to have some logical sequence, the branch lines are described in order proceeding in a Down direction. Since Derby was the headquarters of the Midland Railway, this company considered trains travelling southwards to be Down. Paddington being the centre of the GWR empire; it followed that trains proceeding north through Worcestershire were Down.

As the county boundary has varied throughout the years, that chosen is as it was in steam days.

Grateful thanks are due to Kevin Boak, the late E. J. M. Hayward and Colin Roberts for various forms of assistance.

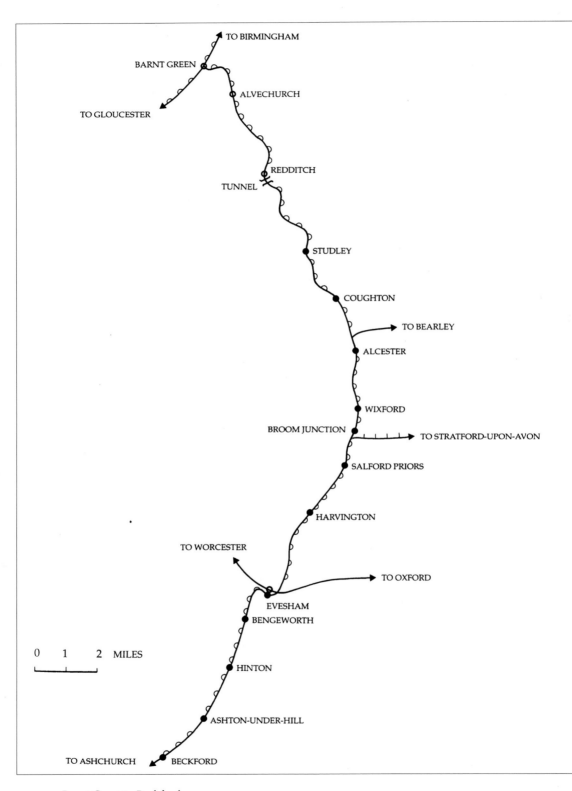

Barnt Greet to Beckford.

Barnt Green to Beckford

Before the opening of the line to Redditch, from 1 November 1856 the Midland Railway operated a horse bus service from its station at Barnt Green via Alvechurch to Redditch.

The first section of the Barnt Green to Beckford and Ashchurch branch was built by the Redditch Railway, an Act of 23 July 1858, allowing the raising of £35,000 in shares and £11,500 by loans. The contractor Thomas Brassey wasted no time: the first sod was cut on 5 August that year and the completed line opened to passengers on 19 September 1859 and to goods on 1 October. It certainly benefited the community; one of the advantages it brought being that reduced transport costs caused the price of coal to fall by 5 per cent. On 1 October 1859 an excursion was run from Redditch to Birmingham Onion Fair for the very reasonable return fare of one shilling. An intermediate station at Alvechurch was opened on 1 November 1859.

Unfortunately the Redditch Railway ran into financial problems as its construction had cost £54,574 against an estimated sum of £35,000. Shares had only raised £27,120, which with the loan of £11,500 left a shortfall of almost £16,000. An Act of 7 August 1862 allowed the company to raise a further £15,000 by shares and a loan of £5,000, or powers to create debenture stock in lieu of loans.

Meanwhile, the Midland Railway Act of 7 June 1861 authorised a branch from Ashchurch to Evesham. Messrs Liddell & Gordon were appointed its engineers and it opened on 1 October 1864 with a procession of dignitaries to Evesham station, followed by a railway trip to Ashchurch. This branch did not entirely satisfy Evesham, which wanted a direct connection with the north. This was provided by the branch built under the Evesham and Redditch Railway Act of 13 July 1863, authorising capital of £140,000 in shares and £49,600 loans. The line was opened to Alcester for goods on 16 June 1866 and to passengers on 17 September the same year. The incomplete 380-yard-long tunnel under the southern part of Redditch prevented the line being opened right through to Redditch. The last portion of the tunnel was cut through on 1 August 1867 and the final section of the Barnt Green to Ashchurch line opened on 4 May 1868. On this date the original Redditch station was closed and a new one opened about a quarter of a mile to the south, close to the north portal of the tunnel. All three sections of the Barnt Green to Ashchurch line were worked by the

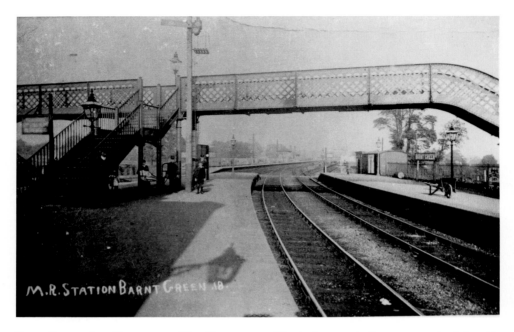

M.R. STATION BARNT GREEN 18.

Barnt Green, view Up, *c.* 1910. The Gloucester to Birmingham main lines are on the left, with the Up platform in the distance. At the top of the signal ladder is a platform to stand on when changing the oil lamp and cleaning the coloured glasses. A newsboy sells papers near the base of the footbridge steps. *Author's collection*

MR, which eventually took over the Redditch Railway in January 1875 and the Evesham and Redditch Railway on 12 July 1882.

In the days before radio, television and telephones it was difficult to get the exact time, so from 12 June 1865 the guard of the 8.35 a.m. Barnt Green to Redditch and the 9.45 a.m. Ashchurch to Evesham was required to set his watch by the starting station clock and give the precise time to each station on the branch.

The line was very useful in providing an alternative route between Gloucester and Birmingham, avoiding the 2 miles of 1 in 37½ up the Lickey Incline. Throughout the year the line carried vegetables from the Vale of Evesham to London: early crops such as cabbages, Brussels sprouts and young onions in March, followed by asparagus until June, which was strawberry time, and around 1904, 30 tons of this crop were carried daily in June and July. In August and September the principal traffic was plums, 1,000 tons being transported weekly, making the winter load of fifteen-twenty wagons of the 1.58 p.m. from Evesham grow to as many as seventy wagons. This load sometimes caused problems on the rising 1 in 67/74 gradient from south of Alvechurch to Barnt Green. It was essential that this train kept to schedule because its load had to be broken at Water Orton to be carried forward by the 4.40 p.m. to Glasgow, the 4.50 p.m. to Carlisle and the 4.55 p.m. to Leeds. Autumn and winter saw the carriage of damsons, tomatoes, marrows, cucumbers, apples and pears.

In March 1958 the whole branch came under Western Region control and on 1 October 1962 the Alcester to Evesham section was declared by the engineer to be unsafe and was closed temporarily almost without warning. Midland Red buses connected Redditch with Evesham, calling at the intermediate stations, until 17 June 1963. The railway passenger service was never reinstated, apart from Alcester and Evesham, as less than twenty passengers used the stations daily. The line closed to goods on 13 June 1964. The Evesham to Ashchurch section closed entirely on 9 September 1963 because it was thought to be uneconomic to carry out the expensive track replacement required.

Although today trains for Redditch start from Lichfield, for most of the life of the branch trains originated from Birmingham (New Street). Barnt Green had two main-line and two branch platforms, the latter sharply curved. An attractive feature of the station is the MR footbridge spanning the four tracks. Today a waiting shelter is provided on the Down branch platform, but passengers on the Up branch platform have to share the Down main-line accommodation; no shelter is located on the Up main platform. Beyond the platforms the branch line falls on a gradient of 1 in 75 and becomes single. The Worcester and Birmingham Canal is crossed on the approach to Alvechurch where the single platform and brick-built office is on the Down side. A new platform costing £232,000, opened on 19 March 1993, was provided immediately on the Barnt Green side of the original. It is in a rural situation and has fields on either side.

Beyond Alvechurch the falling gradient continues to the trailing siding which led to Redditch gasworks. The line became double at Redditch North signal-box near the site of the first station. Before the advent of DMUs six locomotives were stabled at the adjacent one-road engine shed. Built of brick, it opened in 1872-3 and was a sub-shed of Saltley and later Bournville. In 1938-9 Redditch shed was re-roofed, the new structure being almost flat. Although DMUs from the Monument Lane depot began working to Redditch on 25 April 1960, the shed, sub to Bromsgrove since the branch was incorporated into the Western Region, remained open for two locomotives – either a 2-6-4T or 2-6-0 for one passenger train and also parcels working, with an ex-LMS Class 3F 0-6-0T or ex-GWR 0-6-0PT as goods pilot. Following the closure of the shed on 1 June 1964 a diesel shunter was used. The goods yard was quite extensive, having a capacity of 188 wagons, excluding private sidings. An extremely large goods shed was provided for dealing with commodities manufactured locally such as needles, wire, fishing tackle, springs, batteries and bicycles. The yard closed to goods on 8 September 1969, but in the 1970s and early 1980s stone trains arrived at the yard behind a pair of Class 24s, the stone being offloaded into lorries for transit to road construction sites. Frequently all the sidings were full. On one occasion, at Bristol Parkway, a shunter directed a locomotive into the wrong siding and, instead of picking up full wagons for the M42 motorway construction, was coupled to empties. The error was not spotted in the dark and only revealed when it arrived at Redditch. As the material was required immediately, a special had to be run.

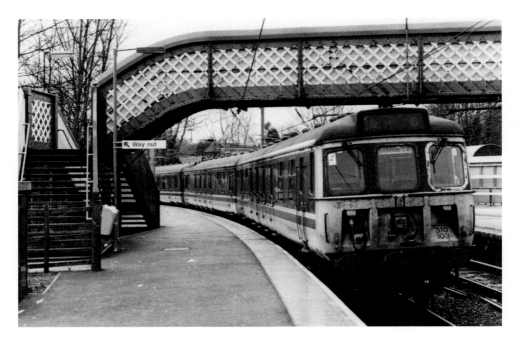

Rear view of EMU No. 310 103 at Barnt Green working the 09.26 Saturdays-only Lichfield (Trent Valley) to Redditch, 5 February 1994. Its rear destination blind (Lichfield Trent Valley) could be misleading. The train's state sadly contrasts with that of 2-4-0 No. 176 on page 36. The magnificent MR footbridge still stands. *Author*

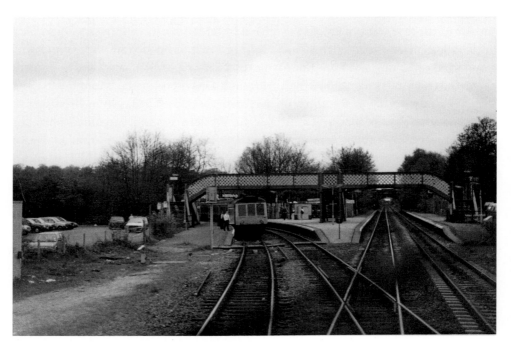

A Down HST driver's view of the junction at Barnt Green, 11 May 1991. A DMU to Redditch stands at the branch platform. *Author*

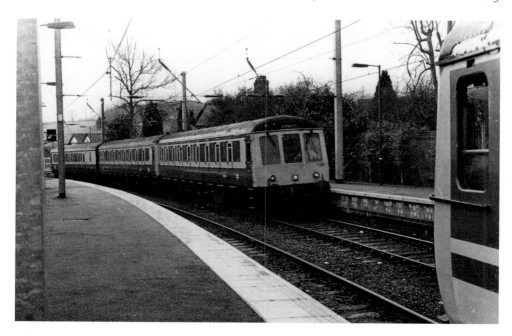

DMU No. T321, on 5 February 1994, works the 10.24 Redditch to Lichfield (Trent Valley) under the wires, while on the right No. 310 103 works the 09.26 Lichfield (Trent Valley) to Redditch. *Author*

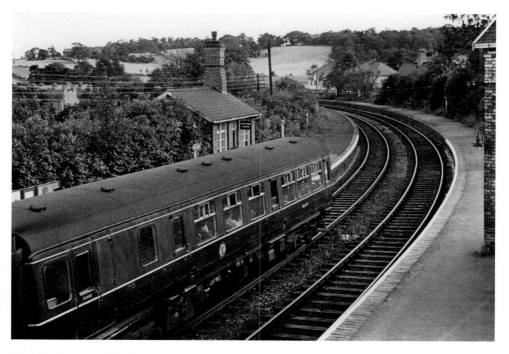

The sharply-curved platforms at Barnt Green with the countryside beyond are illustrated well in this photograph. A two-car Park Royal DMU is working the 15.32 Birmingham (New Street) to Redditch, 19 September 1964. *Michael Mensing*

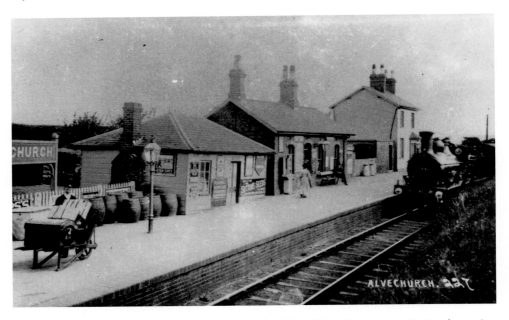

A 2-4-0, probably No. 104A, arrives at Alvechurch with an Up train, *c.* 1905. Notice the station master's house, the brick-built station office and a supplementary one of timber, with, in the interests of safety, a brick chimney. There are an abundance of advertisements. Notice the barrels, cases, trunks and milk churns – the railway was an important carrier. *Author's collection*

The original station at Alvechurch has now become redundant and been replaced by a structure immediately to the north. The station house is being demolished in this 5 February 1994 view and the site of the timber-built office is occupied by a bus stop-type shelter. The platform edge has been cut back. The view is towards Redditch. *Author*

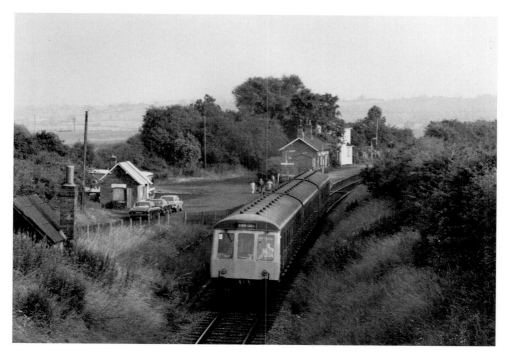

The 18.41 Redditch to Four Oaks leaves Alvechurch on 15 July 1978. *Michael Mensing*

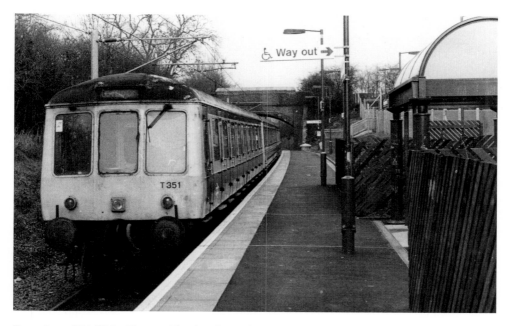

Rear view of DMU Set T351 at Alvechurch, working the 09.24 Redditch to Lichfield (Trent Valley), 5 February 1994. This platform opened on 19 March 1993 and, being almost straight, offers a better view of boarding and alighting passengers. It is also sited nearer the road. *Author*

Left: This sign opposite the platform at Alvechurch helps to prevent a stranger getting on a train going in the wrong direction, 5 February 1994. *Author*

Below: A Down train comprising seven six-wheeled coaches at Redditch, *c.* 1905, viewed towards the tunnel, while an Up train arrives. *Author's collection*

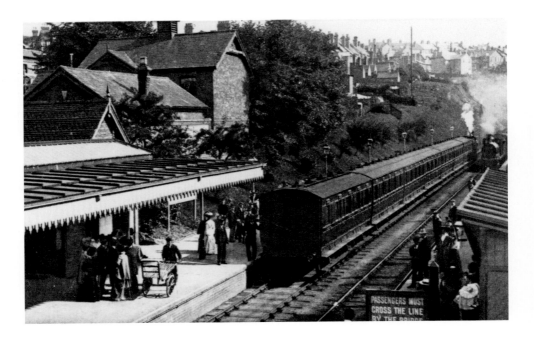

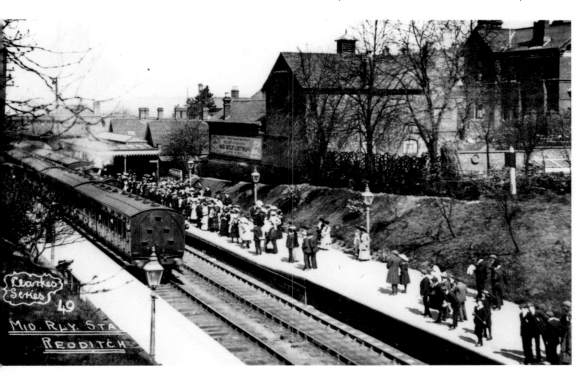

Redditch: an Up train stands on the left as a Down train enters, *c*. 1910. Its coaches will be well filled. *Author's collection*

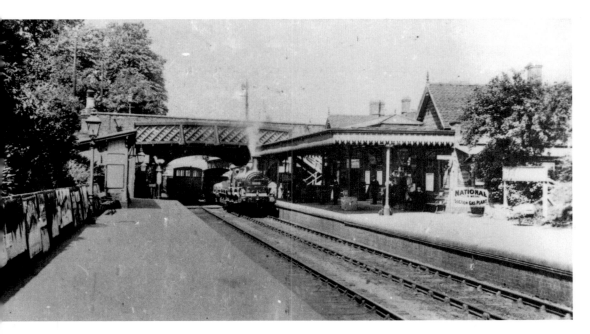

Two goods trains pass at Redditch, *c*. 1910. The Down train on the right is headed by a Kirtley double-framed 0-6-0. *Author's collection*

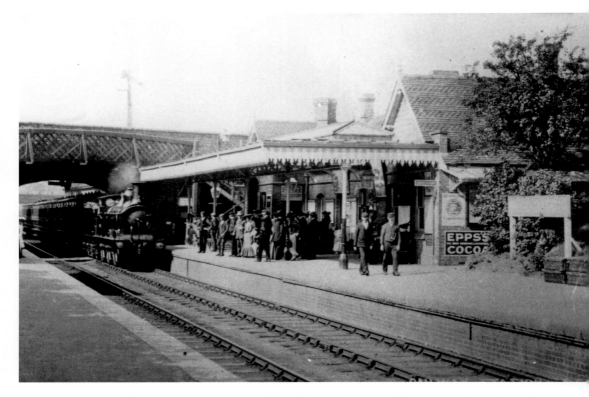

A seven-coach Down train arrives at Redditch headed by a 0-6-0. The canopy valence is worth a second look. The card is postmarked 4.12.05. *Author's collection*

The two-road passenger station at the south end of the complex was built of brick. In 1972 this was replaced by a single platform with two faces sited a little nearer Barnt Green, but by September 1986 one-train working had been instituted between Barnt Green and Redditch so only one road was used. On 28 May 1993 the fourth Redditch station was opened. The platform has a single-storey, red-brick building and forms the terminus of the electrified Cross-City line. It is situated at the Midland Railway's 56¾ mile post, this distance being from Derby.

The line became single at Redditch South signal-box and one fireman remembers that during the Second World War a young signalwoman there, when giving the single-line tablet, came so close to the engine that footplate crews believed she would be struck, yet judged it correctly and was quite safe. South of the station the now-lifted line passed through a 380-yard-long tunnel where clearance was very restricted – in fact if a locomotive stopped in the tunnel, there was hardly room at the side to get down from the cab. To avoid a blowback, it was necessary to turn the blower on before entering the tunnel. If an engine slipped to a standstill on the rising gradient of 1 in 126 for Down trains, the crew placed a wet damper over their noses and lay on the floor to catch the freshest air.

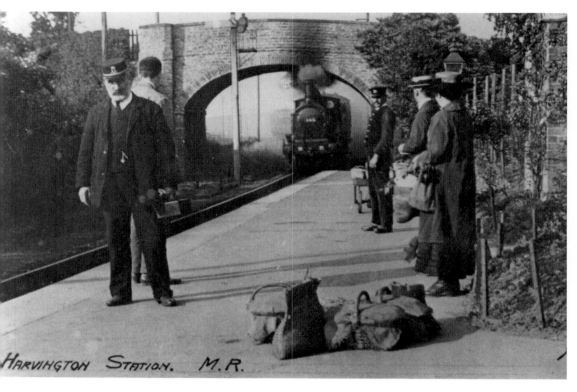

1282 class 2-4-0 No. 163 enters Harvington with an Up stopping passenger train, *c.* 1910. Notice the low fence, right, protecting the sloping station garden. *Author's collection*

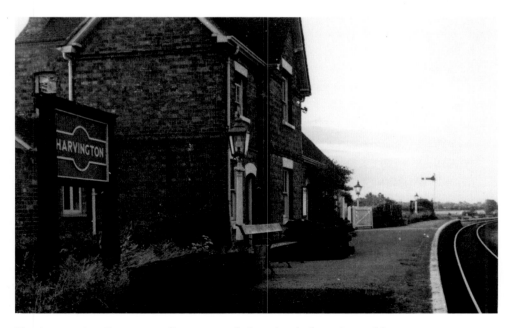

Harvington, view Up, *c.* 1960. Sleepers are piled on the platform. *Lens of Sutton*

Just before Studley the line passed into Warwickshire, only to re-enter Worcestershire north of Harvington. Here the station had a platform on the Up side with buildings of brick, while the small goods yard offered a twenty-five wagon capacity. The station closed entirely on 1 October 1962.

The branch rose at 1 in 137, crossed the GWR's Oxford to Worcester main line and became double before entering Evesham station adjacent to that of the GWR – both served by the same approach road. The temporary station opened on 1 July 1864 was replaced by a permanent structure on 1 October. The substantial brick-built office block stood on the Up platform, but the Down platform lacked a shelter. In postwar years an economy was made by closing the booking office, passengers purchasing their tickets from the ex-GWR station. Near the Down passenger platform was a goods shed and a large fruit store. A junction with the GWR was opened by 23 January 1868. The 1960 Sectional Appendix to the Working Time Table warned that when transferring wagons between the former GWR and LMS lines, 'Before any vehicles are placed in this siding, or vehicles standing in the siding are set back towards the Worcester line, care must be taken to ascertain that vehicles are not being placed on the siding at the Worcester end.' It sounds as though this rule was prompted by a mishap, which was usually when such instructions were issued.

Another local regulation read: 'Guards of trains brought to a stand on the Down line clear of the connection from the Up line to the Single line must immediately advise the Signalman at Evesham box that the train has arrived with the tail lamp attached.' This instruction was introduced due to the signal-box being sited at the south end of the passenger station, being in this position it meant that the signalman could not see if a Down train was complete and had not blocked the signal line with uncoupled vehicles which could be struck by an Up train.

The goods depot was renamed Evesham South on 4 September 1951 and Evesham closed to passengers on 17 June 1963. South of the goods sidings was the two-road engine shed opened in 1870-1 and a sub-depot of Gloucester. Although closed on 14 September 1931, in 1954 engines were still stabled there.

The line between Evesham and Beckford was worked by telegraph bells prior to the introduction of the block telegraph system. West of Evesham the line, doubled to Ashchurch on 23 September 1890, crossed the Avon. Bengeworth, with a yard capacity of twenty-four wagons, closed to passengers and goods on 8 June 1953. As a wartime economy measure, single-line working was introduced between Bengeworth and Beckford on 31 January 1917, the Up platform being used at Ashton and the Down at Hinton. Double track was restored on 22 February 1921.

The line rose at 1 in 210 to Hinton which had a stone building, unstaffed from 31 August 1953. It closed to passengers on 17 June 1963 and the thirty-two-wagon goods yard closed a fortnight later on 1 July.

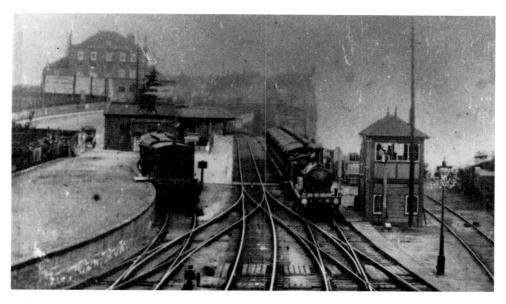

A general view of the MR station at Evesham, *c.* 1910. The goods sidings are on the right, a Down passenger train headed by a 2-4-0 stands at the platform, while to the left is the carriage dock. Just off the picture to the left is the GWR. *Author's collection*

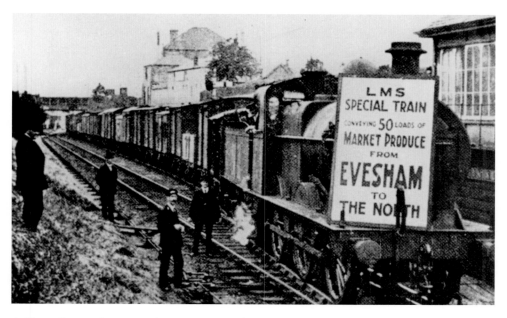

A Class 3F 0-6-0 leaves Evesham, *c.* 1929, with an Up market produce special. The notice reads: 'LMS special train conveying 50 loads of market produce from Evesham to the North.' It stands by Evesham North signal box which closed on 20 January 1935. *Author's collection*

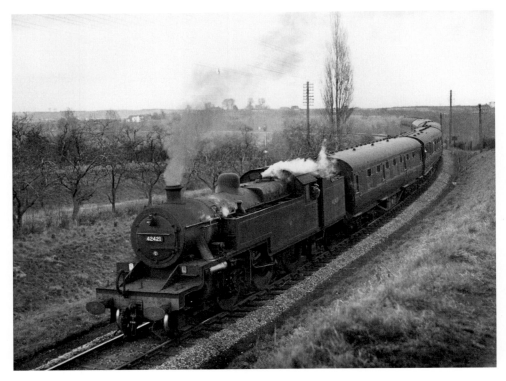

Fowler Class 4 2-6-4T No. 42421 (21A Saltley) crosses the ex-GWR line (a WR signal can be seen above the cab) and approaches Evesham station with the 5.10 p.m. Birmingham (New Street) to Ashchurch, 14 April 1962. *Michael Mensing*

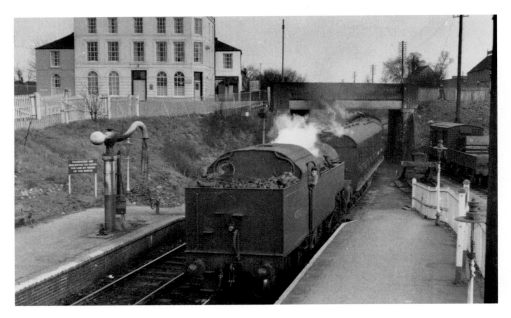

Fowler Class 4 2-6-4T No. 42337 arrives at Evesham with a Down train in March 1958. *P. Q. Treloar*

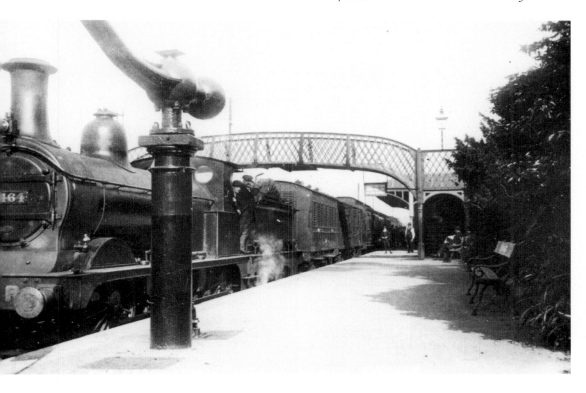

Above: An Up strawberry special leaves Evesham behind Class 2F 0-6-0 No. 3464 (7 Gloucester), *c.* 1920. In the foreground is the massive base of a water crane. *Lens of Sutton*

Right: Fowler Class 4 2-6-4T No. 42416 at Evesham with the 4.30 p.m. Ashchurch to Redditch, 14 April 1962. The ex-GWR station can be seen beyond the tree. *Michael Mensing*

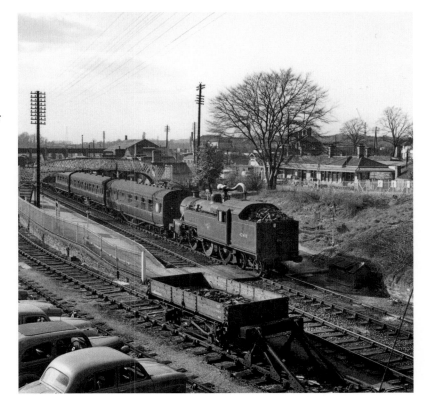

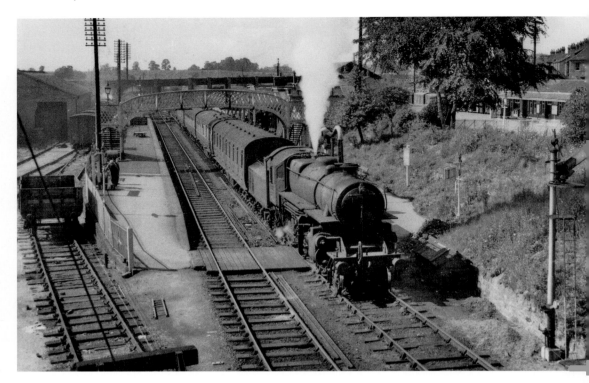

Ivatt Class 4 2-6-0 No. 43036 has steam to spare as it heads an Up stopping train at Evesham, *c.* 1955. *Lens of Sutton*

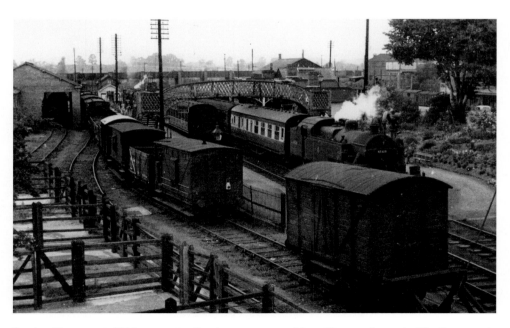

Fowler Class 4 2-6-4T No. 42326 at Evesham, *c.* 1952, with an Up stopping train. The Down train is headed by a Class 5 4-6-0. The station garden on the right looks attractive. Cattle pens are on the left. *Lens of Sutton*

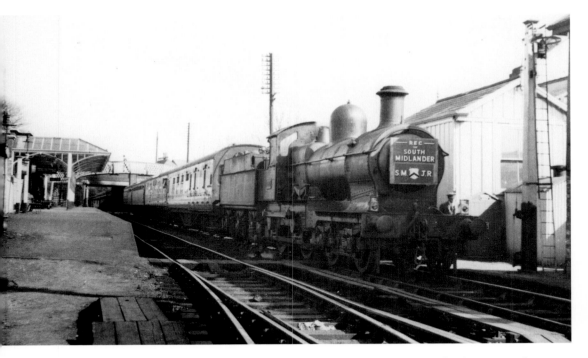

90XX class 4-4-0 No. 9015 works the Railway Enthusiasts' Club 'The South Midlander', 24 April 1955. It has arrived at Evesham in the Down direction. *M. E. J. Deane*

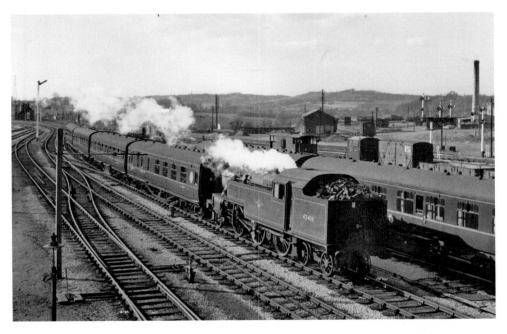

Fowler Class 4 2-6-4T No. 42416 arrives at Evesham on 14 April 1962 with the 4.30 p.m. Ashchurch to Redditch. *Michael Mensing*

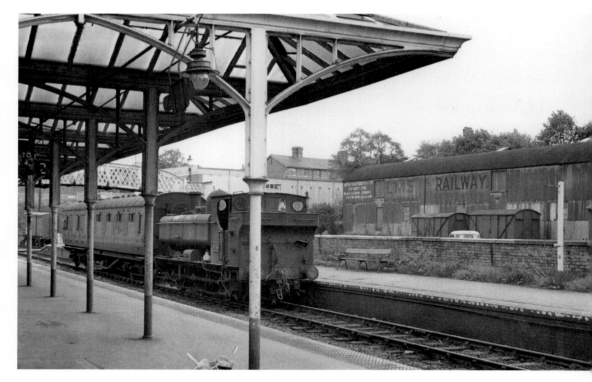

57XX class 0-6-0PT No. 8743 at Evesham with the 6.47 p.m. to Ashchurch, 18 May 1963. On the right is the former LMS Railway's fruit store, then in use for storing chip baskets. *Michael Mensing*

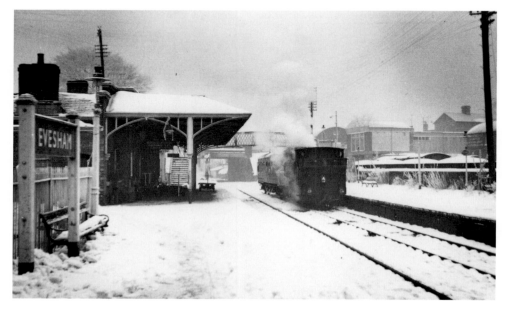

57XX class 0-6-0PT No. 8743 at Evesham with the 12.24 p.m. to Ashchurch, 12 January 1963, during the 'Big Freeze'. *E. Wilmshurst*

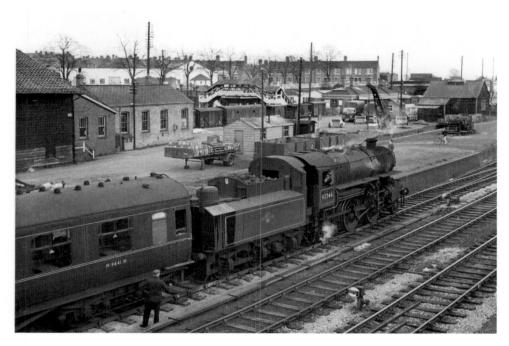

Ivatt Class 4 2-6-0 No. 43046 reversing into a siding west of Evesham station on 14 April 1962, after arriving with the 1.06 p.m. ex-Birmingham (New Street) and running round. The nearest trailer is loaded with vegetable crates, while beyond are hay-making rakes. The ex-GWR station can be seen beyond the crane. *Michael Mensing*

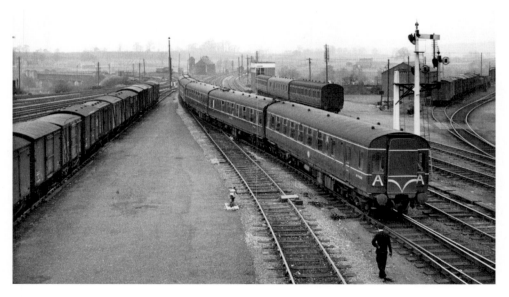

A six-car Swindon Inter-City DMU at Evesham on Sunday, 30 May 1958, crosses from the ex-MR's Ashchurch line to the ex-GWR metals. The 9.00 a.m. Swansea to Birmingham (Snow Hill) used this route when the line through Broadway was closed for extensive permanent way works. The former GWR engine shed is just to the right of the rear of the train and the flat-roofed signal box opened only the previous year on 15 March 1957. *Michael Mensing*

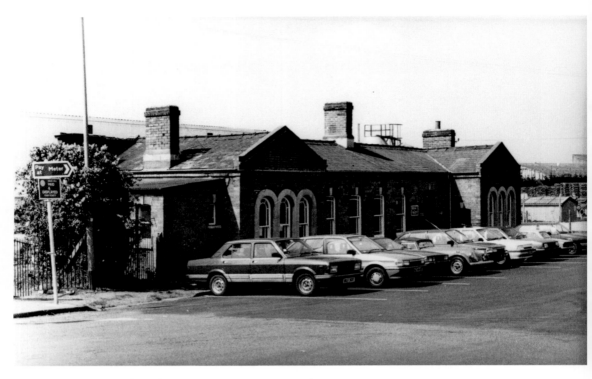

The exterior of Evesham station, 7 May 1987. *Author*

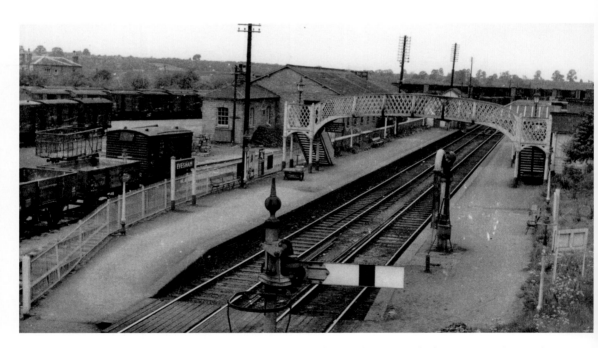

Evesham, view Down, *c.* 1960. No shelter is provided on the Down platform. Notice the goods yard, left, crowded with vans. To the left is a caged trailer for conveying fruit and vegetable produce. *Lens of Sutton*

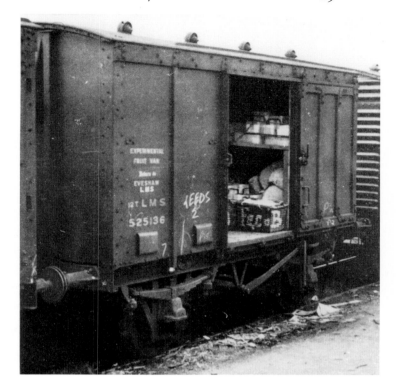

LMS experimental fruit van No. 525136 at Evesham in April 1946. Of the 25,000 LMS vans of this type, only six experimental vans were constructed and these were built at Wolverton in 1945. *Author's collection*

The well-maintained garden at Bengeworth can be seen beyond the waiting shelter on the Down platform, *c.* 1935. A notice on the building reads: 'You may telephone from here.' This was a common facility for the public to use a railway phone on payment of the usual charge. *Lens of Sutton*

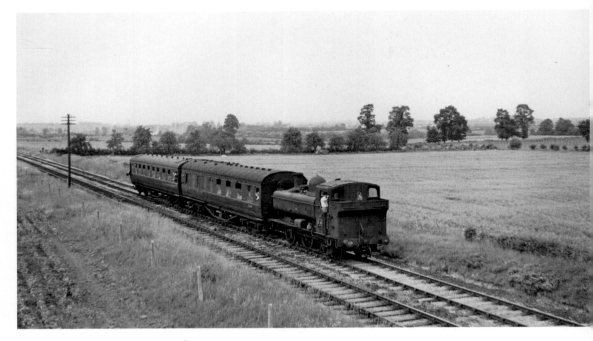

8750 class o-6-oPT No. 3745 approaches Hinton with the branch's last passenger train, the 6.47 p.m. Evesham to Ashchurch, on 15 June 1963. *Michael Mensing*

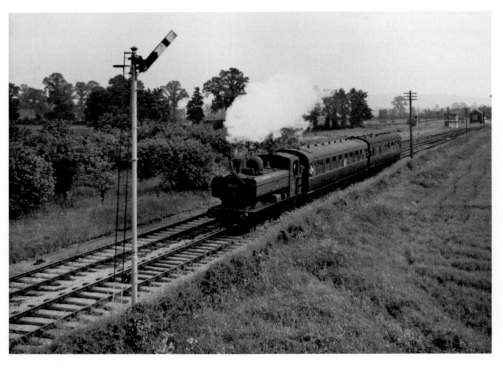

8750 class o-6-oPT No. 3745 leaves Hinton with the last Up train, the 4.30 p.m. Ashchurch to Evesham, on 15 June 1963. *Michael Mensing*

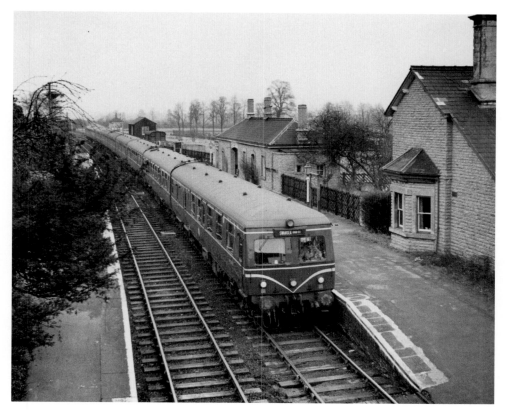

Three sets of three-car Swindon Cross-Country DMUs pass Hinton on Sunday 30 March 1958 forming the 9.00 a.m. Birmingham (Snow Hill) to Swansea service, engineering works having diverted it from the usual route via Broadway. *Michael Mensing*

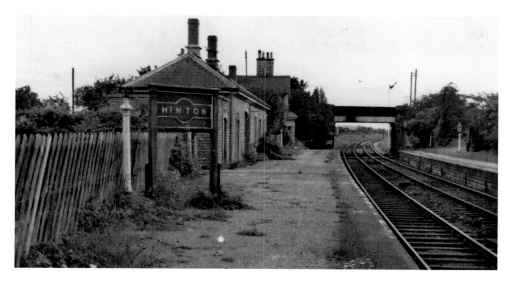

Hinton, view Down, *c.* 1964. Closed to passengers on 17 June 1963, it is showing signs of neglect. *Lens of Sutton*

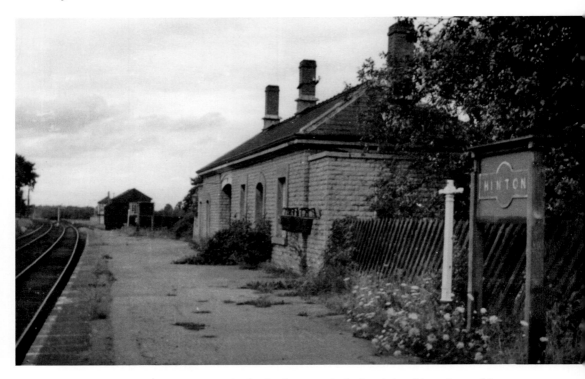

Hinton, view Up, *c.* 1964. Notice the fire buckets, goods shed and signal box. *Lens of Sutton*

The summit was reached about midway between Hinton and Ashton under Hill and the line fell at 1 in 210/286 to Beckford. Ashton also had stone buildings and was unstaffed from 1 March 1957. The goods yard held thirty-eight wagons and the station closed entirely on 17 June 1963. Its signal box had closed on 25 January 1910, when a ground frame was provided in lieu. Beckford ceased to deal with passengers on 17 June 1963 and goods on 1 July. James Taylor & Co. had a sizeable depot in the yard and supplied coal, coke and building materials over a large area. Fruit vans were despatched from the yard during the season. Beckford had a capacity of seventy-eight wagons.

The branch has seen quite a variety of locomotives. In the early days 2-4-0s, and Kirtley and Johnson 0-4-4Ts worked passenger trains, with the occasional appearance of a 4-4-0.

In 1907-8 Deeley 0-6-4Ts appeared and in 1934 four members of this class were shedded at Redditch. No. 2023 disgraced herself early in 1935 when she derailed at speed between Ashton under Hill and Beckford, killing Driver A. Wolley. Subsequently a 40 mph restriction was imposed on this stretch of line. Later tests proved that these engines were only suitable for working up to about 50 mph and above this speed riding was rough, oscillation and roll pronounced, and there was a tendency for the front end to develop an up and down surging movement. They did not enjoy longevity, for the last member of this class was

scrapped in 1938. In June 1935 trains on the line were being worked by Tilbury 4-4-2Ts and Class 3 non-superheated 0-6-0s. The 0-6-4Ts were replaced by 2-6-2Ts and Fowler 2-6-4Ts.

In the immediate post-war years Stanier Class 3P 2-6-2Ts Nos 97, 115-117, 171/4/5 were allocated to Saltley and appeared on the branch. Four Fowler Class 4P 2-6-4Ts were also utilised – two from Saltley shed and two from Bourneville. The four engines working from Redditch shed in the week ending 6 February 1954 were Class 3P 2-6-2T No. 40117 and Class 4 2-6-4T No. 42338, both of 21B Bournville; Class 3F 0-6-0 No. 43599 and BR Class 4 2-6-4T No. 80063, both of 21A Saltley. Later, Ivatt Class 4 2-6-0s appeared and in 1960 newer ex-LMS 2-6-4Ts with side-window cabs. On summer Saturdays in 1962, an ex-LMS Class 3F 0-6-0T worked a 57-mile round trip from Redditch to Ashchurch and back with four to six coaches.

Freight was generally handled by 0-6-0s, Class 5 4-6-0s and Class 8F 2-8-0s. In 1957 BR Standard Class 9F 2-10-0s appeared on the Washwood Heath to Westerleigh fitted freights.

Some engines from Redditch to Ashchurch workings travelled to Tewkesbury shed for servicing: e.g. on 8 September 1960 Class 3F 0-6-0Ts, Nos 47422 and 47539, and Class 4 2-6-4Ts, Nos 42416 and 42417.

The closure of the Alcester to Evesham section in October 1962 severed the southern part of the branch from Redditch shed. So as the branch had come under WR control from March 1958, WR locomotives from Cheltenham operated Ashchurch to Evesham trains.

Banana specials worked from Avonmouth to London via the MR and Stratford-upon-Avon and Midland Junction Railway, using the branch between Ashchurch and Broom Junction. The Barnt Green to Ashchurch line was valuable during both World Wars as an alternative route to the main line, also handling traffic from the London and North Eastern Railway via the former SMJR. On 4 June 1951 iron ore trains began operating from Woodford Halse and Banbury to South Wales, usually hauled by ex-WD 2-8-0s. Branch signal-boxes south of Broom Junction were kept open all night to handle this traffic, though in 1960 it was diverted at Stratford-upon-Avon to the former GWR line to Honeybourne and Cheltenham.

When the branch opened throughout from Barnt Green to Ashchurch the passenger service consisted of four trains each way and two on Sundays. By August 1887 four Down trains ran throughout and two in the Up direction, plus two more between Evesham and Barnt Green and seven more from Barnt Green to Redditch. By July 1922 the timetable showed three Down and two Up trains plus about nine short workings each way, while on Sundays two trains were run from Barnt Green to Evesham and back. July 1938 had a much better service: seven through trains each way plus about seven more from Barnt Green to Redditch. On Sundays five trains ran to and from Evesham, plus nine short workings to and from Redditch and an anglers' train ran from Birmingham to Evesham.

Ashton under Hill, *c.* 1964. A small stone-built waiting shelter stands on the Down platform on the left. *Lens of Sutton*

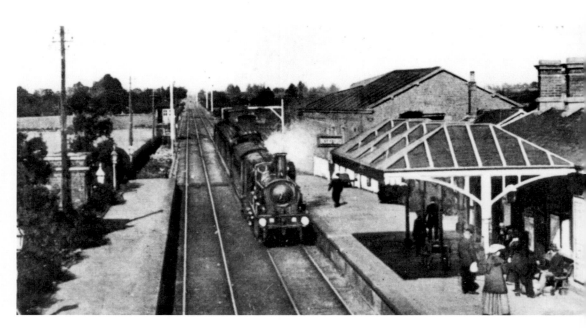

A Down stopping train arrives at Beckford, *c.* 1910. Notice the wide, relatively short platform canopy. *Author's collection*

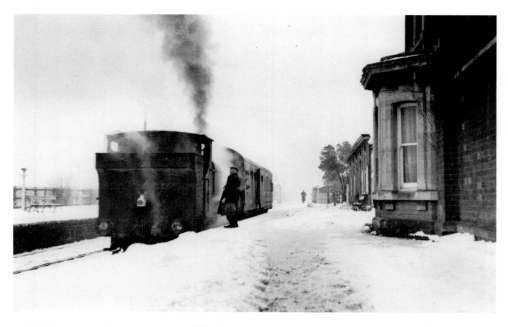

57XX class 0-6-0PT No. 8743 at Beckford on 12 January 1963 with the 11.38 a.m. from Redditch to Ashchurch. *E. Wilmshurst*

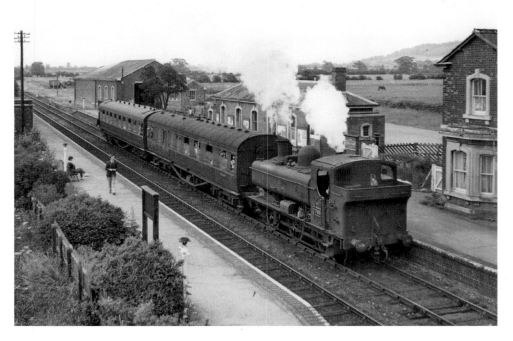

8750 class 0-6-0PT No. 3745 calls at Beckford with the branch's last passenger train, the 6.47 p.m. Evesham to Ashchurch, 15 June 1963. The 'B' headlamp is in the upper position on the bunker. *Michael Mensing*

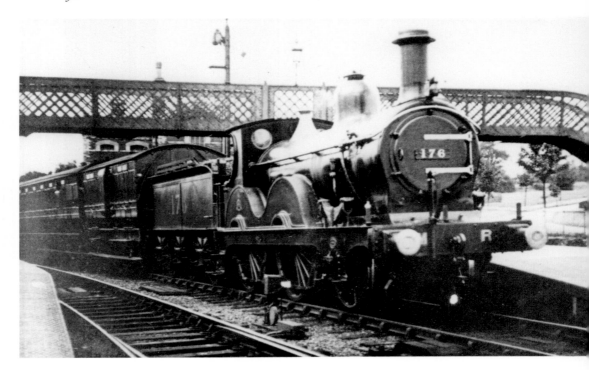

1282 class 2-4-0 No. 176 at Barnt Green with an Up stopping passenger train, *c.* 1910. Notice the beautifully clean condition of the engine, including burnished buffers and smoke box door hinges. *Author's collection*

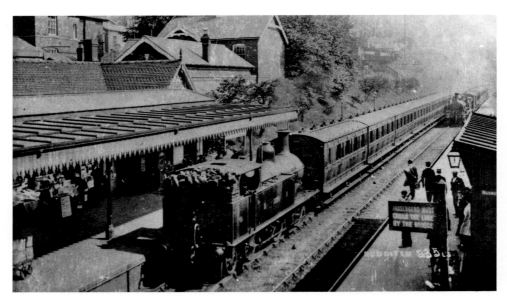

Redditch, *c.* 1910: a 0-4-4T, probably No. 1250, has run round its Down train and awaits a path across to the Up platform after the Up stopping passenger train headed by a tender engine has cleared the section. Notice the very well-filled bunker on the 0-4-4T. The seven-coach train appears to consist of five-compartment stock. A bookstall is on the left. *Author's collection*

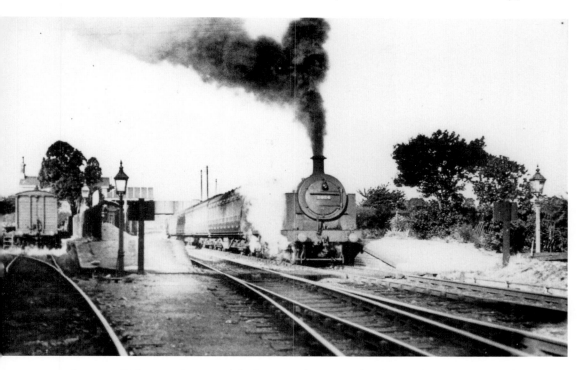

2000 class 0-6-4T No. 2024 leaves Beckford on 23 July 1934 with a five-coach Up train and leaks steam at every conceivable place. This engine was withdrawn in June 1937. The class was known as 'Flat Irons'. *Lens of Sutton*

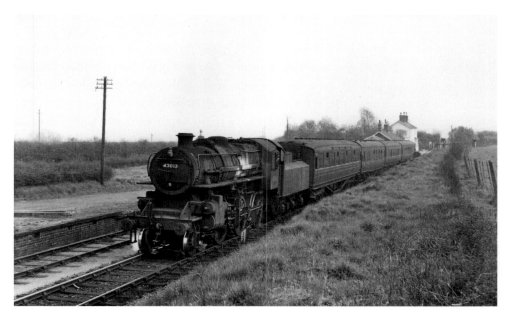

Ivatt Class 4 2-6-0 No. 43013 (21A Saltley) leaves Alvechurch with the 4.25 p.m. Ashchurch to Birmingham (New Street) on 23 April 1960, the last day of scheduled all-steam working on this line north of Redditch. The first coach is an ex-LNER vehicle. *Michael Mensing*

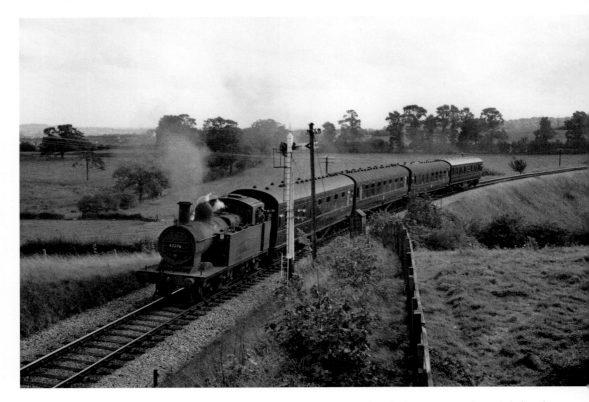

Class 3F 0-6-0T No. 47276 passes Redditch Up distant signal with the 1.15 p.m. from Ashchurch on 29 September 1962, the last day of passenger traffic. *Michael Mensing*

The introduction of DMUs on 25 April 1960 brought an hourly service to Redditch, though this was reduced to only two a day in 1964. However, the development of Redditch as a New Town with a population explosion from 25,000 to 65,000, saw the service increased dramatically. An average of 250 passenger journeys daily in 1978 rose to 650 in October 1980 and 1,030 in November 1981, the line being boosted by the Redditch and Alvechurch Rail Users' Association founded in 1980. The publicity folder for the branch service in 1982 stated: 'If you have a valid rail ticket you can return from Birmingham on the Midland Red bus.' This information was amplified in the Redditch *London Saver* leaflet: 'Upon arrival at Birmingham (New Street) after 17.45 Mondays to Saturdays [the last train to Redditch departed at 17.48] passengers returning to Redditch may by surrendering their London Saver tickets at New Street booking office, obtain a ticket enabling them to return to Redditch by scheduled Midland Red bus service without extra charge. Passengers must satisfy themselves that a bus service is available and British Rail accept no responsibility for the suspension of bus services nor will any refund be allowed in this respect.'

The first electric train to Redditch was unit No. 310 106 forming the 16.15 from New Street on 24 June 1993 – seventeen days early. DMUs deputised for failures.

Today the operating company London Midland offers a half-hourly service of thirty-five Down and thirty-four Up trains on weekdays and twenty-nine and twenty-eight respectively on Sundays. In August 1887 the journey time from New Street to Redditch was about fifty-five minutes, compared with thirty-nine today. Slight delays can occur at Barnt Green when a Down train has to wait for an Up to clear the single track, or an Up train has to wait to move on to the main line. While there are aspirations to increase the present half-hourly service, capacity does not exist on the single line without installing a loop at Alvechurch.

Table 263 BIRMINGHAM, REDDITCH, EVESHAM, and ASHCHURCH

Miles		Week Days						Suns				Week Days					Suns			
		a.m	a.m	p.m.	p.m	p.m	a.m	a.m				am	am	a.m	p.m	p.m	p.m	a.m	pm	
	Birmingham (NewSt) dp	6 32	8 35	12 20	1 35	5 07	21	5 63		264**Great Malvern B** dp		7 50	1 24	..	6 0			
10¾	**Barnt Green** „	7 39	7	12 48	2 9	5 308	0	37 7 6		264**Tewkesbury B** „		9 0	1 53	..	6 38			
15¾	**Redditch** „	7 27	9 22	1 5 5	2 24 5	55 8	23	53 722		**Ashchurch** dep		710	..	9 30	2 9	4 30	7 35			
18¾	**Studley & Astwood Bank**	7 34	9 28	1 11	2 30	6	18 29	59 72		**Beckford**		717	..	9 37	2 16	4 37	7 42			
21	**Coughton**	7 38	9 33	1 16	2 36 6	6 8	34	..		**Ashton-under-Hill**		723	..	9 43	2 22	4 43	7 48			
23	**Alcester**	7 44	9 39	1 21	2 42 6	13 8	44 9	7 736		**Hinton**		9 49	..	4 50	7 54			
25	**Wixford**	7 49	9 44	..	2 47 6	20	..	9 12 741		**Bengeworth**		733	..	9 54	2 32	4 55	7 59			
25¾	**Broom Junction** arr	7 52	9 47	..	2 50 6	23 8	52 9	15 744		**Evesham** arr		738	..	9 59	2 37	5 0	8 4			
33¾	266**Stratford-on-** arr	8 52	9 21	..		**Oxford** dep		..	7 42	11 35	3 30	6 20	..			
	Avon B dep	7 22	..	1028	..	7 55		**Evesham** dep		..	742	1044	2 39	5 8	9 9	50 815		
—	**Broom Junction** dep	8 19	48	..	2 57 6	24 8	53 9	16 745		**Harvington**		..	750	1053			
27	**Salford Priors**	8	5 9 52	..	3 1 6	28 8	57 9	2 749		**Salford Priors**		..	756	1059	2 52	5 20	8 24	10 4 829		
29	**Harvington**	8 11	9 57	..	3 6 6	33 9	2 9	25 754		**Broom Junction** arr		..	759	11 2	..	2 55	5 23	8 28 10 7 832		
32¾	**Evesham** arr	8 19	10 3	..	3 14 6	39 9	8 9	31 8 0		266**Stratford-on-** arr		..	852	9 21	..		
75¾	**Oxford** arr	10 61	5	..	5 25 9	25	..	1 10		**Avon B** dep		..	722	1028	7 55	..		
—	**Evesham** dep	8 21	10 9	..	3 20 6	44 9	11	..		**Broom Junction** dep		..	8 1	11 7	..	2 56 5	25 8	33 10 8 833		
34¾	**Bengeworth**	8 27	1015	..	3 26 6	50		**Wixford**		..	8 5	1111	p.m	..	5 29	..	1012 837	
35¾	**Hinton**	8 32	1020	..	3 31 6	55		**Alcester**		710	811	1117	1 42	3 3 5	35 8	40 1018 843		
37¾	**Ashton-under-Hill**	8 38	1026	..	3 37 7	1		**Coughton**		..	817	1123	..	3 9 5	41	..		
39¾	**Beckford**	8 44	1032	..	3 43 7	7		**Studley & Astwood Bank**		719	823	1129	1 51	3 15 5	47 8	49 1027 852		
43¾	**Ashchurch** arr	8 51	1039	..	3 49 7	14 9	30	..		**Redditch** arr		726	830	1136	1 58	3 22 5	54 8	56 1034 859		
45¾	264**Tewkesbury B** arr	9 32	1236	..	4 50 7	52		**Barnt Green** „		746	848	1155	2 15	3 39 6	11 9	18 1051 916		
57¾	264**Great Malvern B** „	10 51	10	..	5 49 8	20		**Birmingham** (NewSt) „		819	919	1225	2 44	4 26 6	58 9	48 1125 941		

A 4 mins later on Sats. B Calls to set down. B One class only. S Saturdays only.
For LOCAL TRAINS & intermediate Stations between Birmingham and Barnt Green see Table 261

Above: LMS Timetable October 1941.

Right: Bradshaw's *Railway Guide & Shareholders' Manual*, 1869.

Meetings in February or March, and August or September.

No. of Directors—4; minimum, 3; quorum, 3. *Qualification*, 300*l*.

DIRECTORS:

1 Chairman—HENRY MILWARD, Esq., Redditch.
2 Samuel Thomas, Esq., Redditch; 3 J. E. Clift, Esq., Birmingham.
4 John Osborne, Esq., Redditch.
The figures denote the order of retirement. All eligible for re-election.

OFFICERS.—Sec., Charles Swann, Redditch; Auditors. W. T. Heming, Redditch, and Henry Howell, Birmingham; Solicitors, Browning and Sons, Redditch, and Bolton and Sanders, Dudley.
Offices—Redditch.

293.—REDDITCH.

Incorporated by 21 and 22 Vic., cap. 137 (23rd July, 1858), to construct a line from Redditch to the Midland, at Barnt Green. Capital, 35,000*l*. in 10*l*. shares; loans, 11,500*l*. Length, 4¾ miles. Opened 19th September, 1859. Leased to and worked by Midland.

By 25 and 26 Vic., cap. 214 (7th August, 1862), the company was authorised to raise new capital to the extent of 15,000*l*. on shares at not exceeding 6 per cent.; and 5,000*l*. on loan. Also to create debenture stock in lieu of loans.

The traffic is reported to be increasing, and after meeting preference charges the revenue for the half-year ending 31st December was equal to 2¼ per cent. per annum on the ordinary stock. There was no dividend for the June half-year, in consequence of the new preference stock not having been taken up.

CAPITAL.—The general statement of this account to June 30th gave the subjoined detail of income and expenditure :—

Received.		*Expended.*	
Share capital	£35,000	Preliminary	£384
Preference shares, 5 per cent	240	Land	6,000
Interest on unpaid calls	1,464	Compensation to occupiers	337
Loans on debentures	11,500	Contractor	34,988
Interest on deposits in Court of		Engineer	2,272
Chancery	59	Barnt Green Station, and interest	
Balance	6,196	on onlay, per Midland	1,011
		Roads to stations, &c	979
		Law	5,064
		Parliamentary agents	440
		Secretary's salary to Christmas, 1860	125
		Stourbridge and Kidderminster Banking Co., interest on over-draft	2,855
	£54,459		£54,459

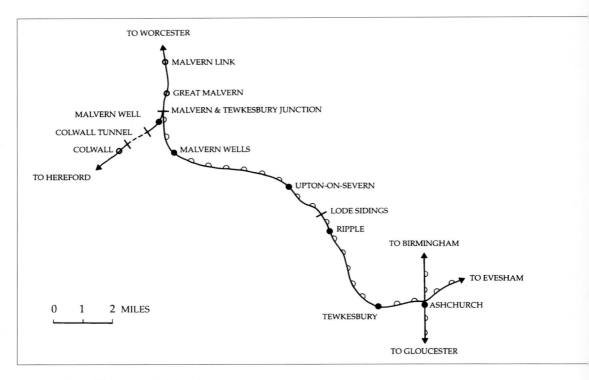

Great Malvern to Ashchurch.

Great Malvern to Ripple

The Great Malvern to Ripple section of the Ashchurch to Great Malvern branch was built by the Tewkesbury and Malvern Railway, which received its Act on 25 May 1860 to raise a capital of £145,000 in shares and £48,000 in loans.

Construction started from the West Midland Railway at Malvern and Tewkesbury Junction and the line opened to Malvern Wells on 1 July 1862, worked temporarily by the West Midland Railway, as the Midland Railway (which was to operate the branch) had no access until the line was completed through to Ashchurch. The line was opened throughout to passengers on 16 May 1864 but unusually for this period there was no opening ceremony. The occasion was not entirely overlooked, however, and early the following month the directors and friends celebrated by holding a banquet and ball at the Star and Garter Hotel, Richmond, Surrey. The fact that the celebration was so far from the railway whose opening they were celebrating was certainly most unusual, if not unique. In pre-radio days it was difficult to determine Greenwich Mean Time, so from 12 June 1865 the guard of the 9.43 a.m. Ashchurch to Malvern was required to set his watch by the starting station clock and give the precise time to each station on the branch.

The Tewkesbury and Malvern Railway was vested in the Midland Railway as from 1 July 1877. Most investors lost a considerable amount of money: only holders of first mortgages were paid in full. Holders of second mortgages received 10 per cent, while Lloyds bonds and shareholders also received just 10 per cent. The Midland Railway possessed running powers to Great Malvern and Malvern Link stations, though excursion traffic could only be worked to the latter. Prior to the introduction of the block telegraph on 8 August 1890, branch trains were kept apart by the time interval system.

The section of line from Malvern and Tewkesbury Junction to Upton was closed to passengers on 1 December 1952 and the track between Malvern Wells and Upton lifted in September 1953. The passenger service between Upton and Ashchurch was withdrawn on 14 August 1961; the last train of two coaches, and thus double the normal length, was hauled by Class 3F 0-6-0 No. 43754. The freight service was withdrawn from Upton and Ripple on 1 July 1963. The line between Malvern and Tewkesbury Junction and Malvern New Midland sidings was closed to goods traffic on 1 May 1968.

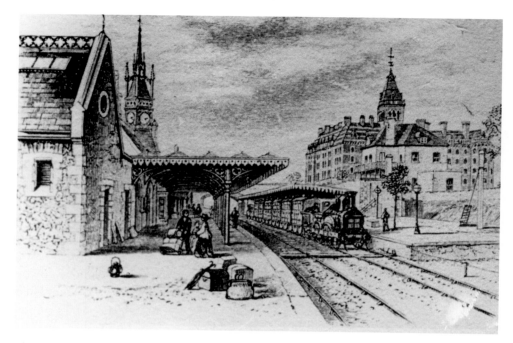

The station and hotel at Great Malvern, *c. 1870. Author's collection*

MR branch trains started from the splendid station at Great Malvern. Now Grade II listed, E. W. Elmslie designed not only the station but also its environs – the landscaped approach road and gardens, the roadbridge and the Imperial Hotel, a luxurious centre for water treatment.

When opened, it claimed to be the only hotel in England lit by incandescent gas. In 1919 this building was purchased by Malvern Girls' College. The single-storey station building was constructed of local stone – Malvern Rag. The clock turret and small spire were removed in the 1950s as Victorian monstrosities, but generally the station has been little altered. Quatrefoils are on the ridge tiles and the same decoration on the awning brackets. Each column supporting the platform canopy has on its capital different flowers and leaves, and in the early 1970s BR allowed a team of volunteers to repaint them in their former vivid colours. The waiting room windows are unusual in having coloured glass. The station, partly destroyed by fire, was rebuilt and re-opened by Sir Robert Reid, BR chairman, on 20 May 1988. It is well worth a visit.

Another interesting and unusual feature is a special subway direct from the Down platform right into the adjacent hotel. At one time there was a siding at the Up end of the Down platform and via a wagon turntable, trucks of coal were taken through a tunnel parallel with the pedestrian subway to the hotel, and later college, boiler room. This siding was taken out of use on 21 October 1956. At least until 1959 water for the college was supplied by the railway from pumps in Malvern Tunnel.

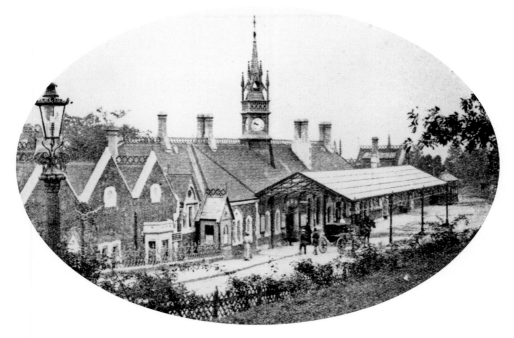

The *porte cochère* and buildings on the Up side, Great Malvern, *c.* 1905. Notice the ornate clock tower, ridge tiles and lamps. The gardens in the foreground were designed by the station's architect, E. W. Elmslie. *Author's collection*

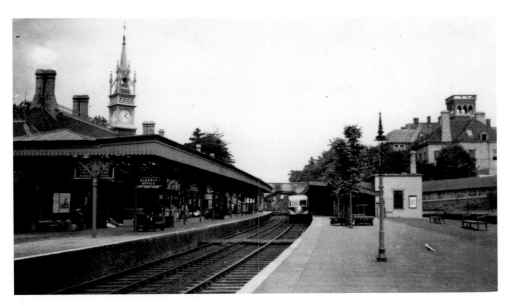

Great Malvern: a streamlined Express GWR diesel railcar lacking drawgear and buffers, arrives at the Down platform, *c.* 1936. A sign reads 'Cloak Room & Great Western Parcels Office', it being a joint station. Notice the covered walkway on the right leading from the Down platform to Malvern Girls' College. The station master's substantial house is beyond. *Lens of Sutton*

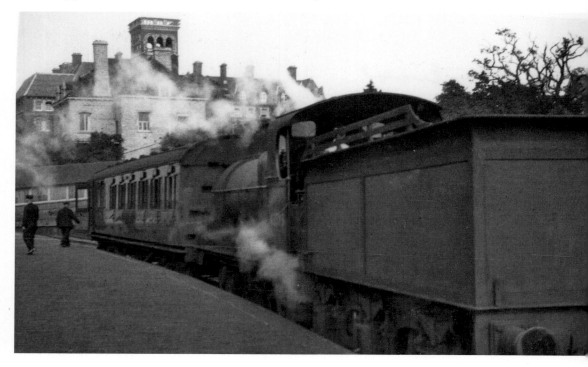

Class 3F 0-6-0 No. 43373 stands in the Down bay platform at Great Malvern, *c.* 1955, with a train to Ashchurch. *Lens of Sutton*

Great Malvern on 23 May 1988, showing the decorated capitals and hanging flower basket. An Up DMU stands at the platform. *J. E. Cull/Colin Roberts collection*

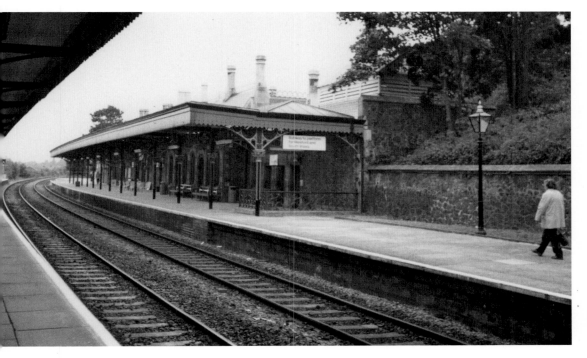

Great Malvern on 23 May 1988. View Down showing the attractive state of the station.
J. E. Cull/Colin Roberts collection

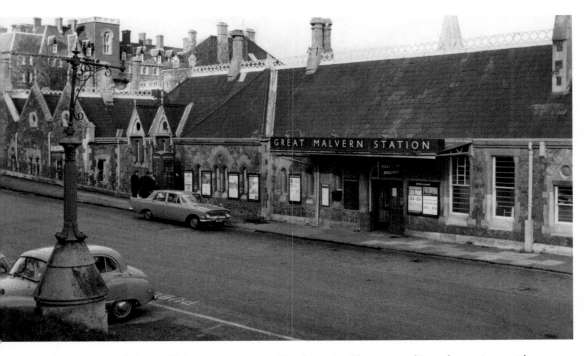

The exterior of Great Malvern station, 27 March 1967. The car parking charge is 2s 6d.
J. E. Cull/Colin Roberts collection

Left: The entrance to the subway on 7 May 1987 from the Down platform of Great Malvern station to the college. The sign on the gate reads: 'Private Entrance Only.' *Author*

Below: The curved subway from the Down platform to the college on 27 March 1967. *J. E. Cull/ Colin Roberts collection*

MR trains generally used the bay at the southern end of the Down platform and travelled for half a mile along the main line towards Hereford before bearing south-west at Malvern and Tewkesbury Junction. Here a single-road engine shed was built in 1864, the gales of January 1866 sweeping off its roof which was replaced by a local builder. In 1883 the shed was renewed in wood at a cost of £126. The branch engine shedded there was normally a Class 1P 0-4-4T. Although the shed closed on 14 September 1931, the adjacent turntable remained in use. The nearby Malvern Sidings were renamed New Midland Sidings in 1946.

From Great Malvern the line fell at 1 in 81 to Malvern Wells, renamed Malvern, Hanley Road on 2 March 1951 to avoid confusion with Malvern Wells on the Hereford line. Hanley Road closed to both passenger and goods traffic on 1 December 1952. The descent continued at 1 in 76/82 to Upton, renamed Upton-on-Severn in April 1889. It had substantial buildings in red and yellow brick. As there were no run-round facilities for a train of any length, a tow rope was kept in the signal-box in order to allow an Up train to shunt, otherwise the engine would have had its exit blocked by wagons. Following the closure of the section to Malvern, it became the terminus of trains from Ashchurch.

Single-line working by pilotman was instituted on the Down line between Upton and Tewkesbury for the week ending 9 July 1913, wagons being stored on the Up line, but the double line was reinstated on 27 August 1913. Single-line working was re-introduced on 18 February 1914 and this mode of operation changed to pilot guard working on 23 February 1914, and working by train staff and ticket from 31 December 1916.

Class 1P 0-4-4T No. 58051 at Upton-on-Severn, c. 1951, with a train for Great Malvern. Notice that the signal arms for opposing directions are unusually on one post.
P. Q. Treloar

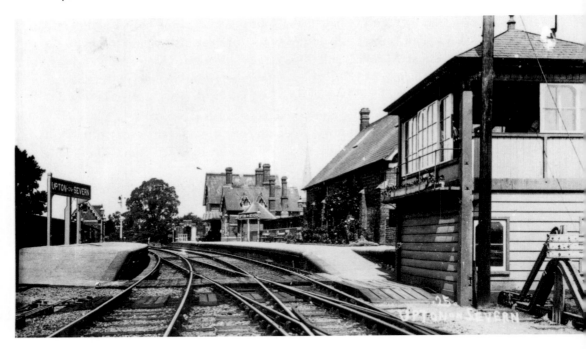

Upton-on-Severn, view Down, *c.* 1910. Notice the substantial goods shed beyond the signal box, the rail-built stop block on the right, and the intricate pointwork in the foreground. *Author's collection*

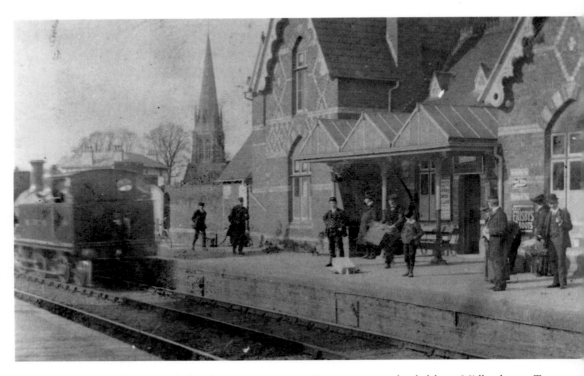

A Great Malvern to Ashchurch train at Upton-on-Severn, *c.* 1905, hauled by a Midland 0-4-4T. Notice the attractive glass canopy and barge boards. *Lens of Sutton*

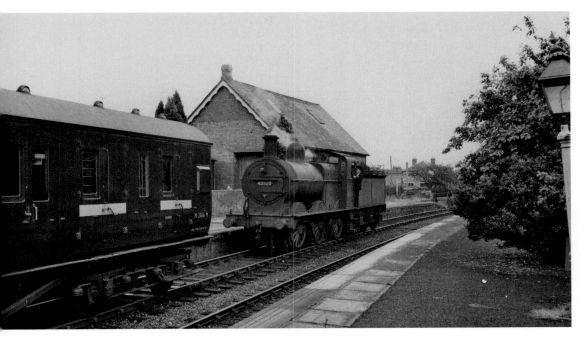

Class 3F 0-6-0 No. 43520 (85B Gloucester) sets back to couple up to the 5.45 p.m. to Ashchurch, 6 June 1959. Notice the goods shed behind the engine. *Michael Mensing*

South of Upton was the 24-yard-long Berry End Viaduct and shortly before Lode Sidings the five-span, 145-yard-long River Severn Viaduct. The latter included a chain driven sliding section over the deepest channel to permit the passage of tall-masted sailing ships. Lode Sidings were brought into use on 2 May 1938 to serve an Air Ministry installation.

The buildings at Ripple were similar, though by no means identical, to those at Upton, one difference being that instead of a light glass canopy over the exit from the booking hall to the platform, the doorway and platform were sheltered by a heavy, protruding gable.

In the early days Kirtley 0-4-4Ts and 0-6-0s worked trains, but in later years passenger trains were worked principally by Johnson Class 1P 0-4-4Ts, although some 0-6-0s appeared, while in the 1940s Fowler and Stanier Class 3P 2-6-2Ts were used. During the Second World War, hospital trains travelled along the line from Ashchurch to Malvern and were usually double-headed. Class 1P 0-4-4T No. 58071, which retained its Salter safety valves until withdrawal in June 1956, was the last Johnson 0-4-4T on the branch. In the late 1950s the branch was the last home of Stanier Class 2P 0-4-4Ts, No. 41900 being the last of its class to work. Earlier in the decade, Nos 41902 and 41903 appeared on the branch. In later years Ivatt Class 2 2-6-0s (No. 46401 was a regular performer) and Fowler Class 3F 0-6-0Ts operated passenger services, but the final trains consisted of a WR 0-6-0PT hauling a single coach.

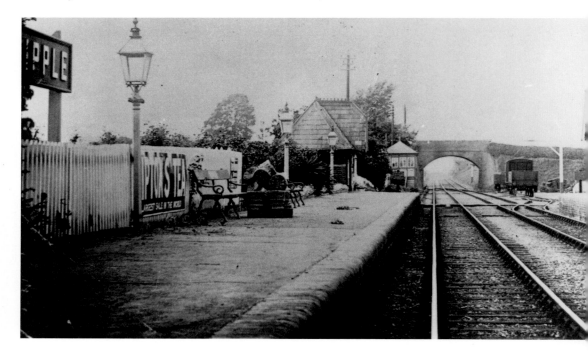

Ripple, view towards Upton, *c.* 1905. Notice the curved edge to the platform, the signal box (closed in 1910) and the fruit baskets piled on the platform and in the goods yard. The track dips under the bridge. *Author's collection*

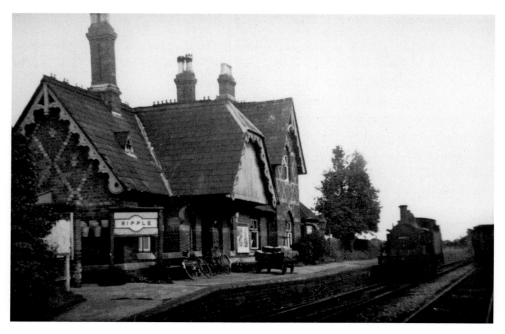

A Class 1P 0-4-4T No. 58071 shunts a goods train at Ripple, *c.* 1952. It still retains the condensing apparatus from the time it worked in the London area. Notice the very heavy protruding roof forming a platform canopy. *Dr A. J. G. Dickens*

57XX class 0-6-0PT No. 7723 with the 1.30 p.m. Upton-on-Severn to Ashchurch, south of Ripple, crosses the M5 motorway under construction on 20 February 1960. *Michael Mensing*

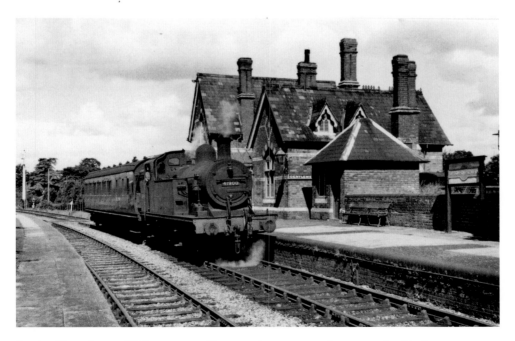

Stanier Class 2P 0-4-4T No. 41900 at Upton-on-Severn on 23 August 1958 with the 1.30 p.m. to Ashchurch. Notice the substantial station buildings relieved with light-coloured brick. *E. Wilmshurst*

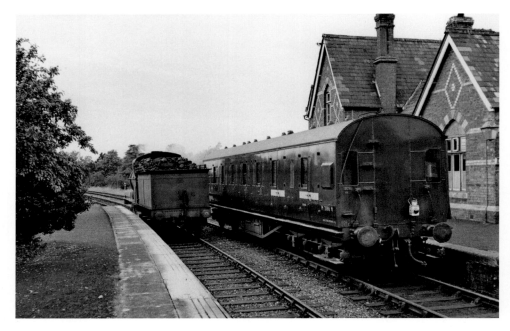

Class 3F 0-6-0 No. 43520, having arrived at Upton with the 5.10 p.m. ex-Ashchurch, is running round the coach to form the 5.45 p.m. return working on 6 June 1959. This engine, together with Nos 43521/3, spent many years allocated to Stratford-on-Avon. *Michael Mensing*

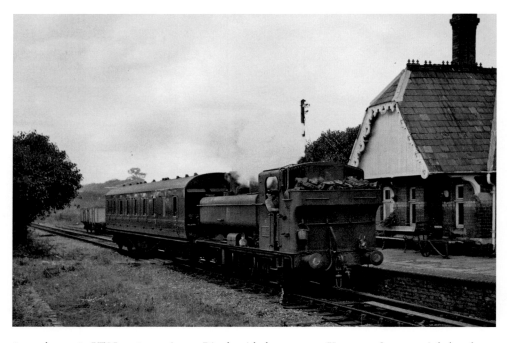

8750 class 0-6-0PT No. 4614 arrives at Ripple with the 5.45 p.m. Upton-on-Severn to Ashchurch, 29 July 1961. The engine draws a 'Pull and Push' coach and carries an incorrectly placed 'B' headlamp while the lower brackets are used for storing the fire irons and bucket. *Michael Mensing*.

An initial service provided four trains each way on weekdays and two on Sundays, but the latter were withdrawn at the end of October 1867. The five trains to Great Malvern in 1880 were reduced to four by 1887. A lunchtime train was added by 1938 but the service was back to four in 1947. By the summer of 1958 the service had declined to two between Upton and Ripple and one in the reverse direction, while on Saturdays an extra train ran each way. This service remained until withdrawal in 1961. In 1890 a through service was inaugurated of one train daily between Malvern and Cheltenham, while in 1902 a through coach was run to Bristol from the branch. The Cheltenham coach was still running in 1946, the single non-corridor vehicle often headed by a Class 2P 4-4-0.

Pre-Second World War evening excursions were run from Bristol to Great Malvern for a fare of 2s 6d. The Class 4F with a load of ten coaches was sorely tested on the 2½ mile climb at 1 in 76/82 from Upton-on-Severn to Great Malvern. On Sundays, trips to Great Malvern alternated with those to Stratford-upon-Avon via Broom Junction.

Although the branch itself was not the scene of a serious accident, when on 8 January 1929 a Bristol to Leeds express overran signals in fog and crashed into a goods train at Ashchurch, the Malvern branch was used as a diversionary route.

Table 264 GREAT MALVERN, TEWKESBURY, and ASHCHURCH (One class only)

Miles	New Street	Week Days only										Miles from Ashchurch		Week Days only						
		a.m	a.m	a.m	non	a.m	pm	p.m	A					am	a.m	a.m		pm	p.m	p.m
	210 BIRMINGHAM....... dep	3 30	..	6 50	..	1030	..	3 20	7 21		210 BRISTOL (Tem.Md.). dep	130	7 50	103)	..	4 54	8 7	0		
	Great Malvern...... dep	7 50	..	1015	..	1 24	..	6 09	..		210 GLOUCESTER........ "	7 18	9 11	1212	..	428	4 50	7 16		
2½	Malvern Wells (Hanley Rd)	7 58	..	1023	..	1 32	..	6 99	..		210 CHELTENHAM SPA C "	7189	.11	1230	..	445	5 10	7 45		
6½	Upton-on-Severn.....	8 6	..	1031	..	1 40	..	6 99	916		Ashchurch....... dep	840	9 27	1250	..	445	5 10	7 45		
8½	Ripple.............	8 12	..	1036	..	1 45	..	6 27	..	1¾	Tewkesbury..........	844	9 32	1236	..	450	5 15	7 52		
12½	Tewkesbury........	8 20	9 0	1042	12 01	53	458 6	3 9 25		5½	Ripple.............	..	9 43	124	5 26	..		
14	Ashchurch....... arr	8 25	..	5	..	12 51	5 8	5 26	4 9 30	7½	Upton-on-Severn......	..	9 48	1253	5 31	8 4		
21½	210 CHELTENHAM SPA C arr	9 2	.53	..	1 24	2 29	..	7 4	1118	11½	Malvern Wells (Hanley Rd)	..	9 59	1 4	5 42	8 14		
27½	210 GLOUCESTER........ "	101	1011	..	1 42	3 0	..	7 5	1135	14	Great Malvern...... arr	..	10 5	1 10	5 49	8 20		
64½	210 BRISTOL (Tem.Md.). "	11½	1122	..	2 48	3 58	..	102	1241	48½	210 BIRMINGHAM (New St) arr	..	1238	6 5	9 32	1032		

A Thurs. and Sats. C Lansdown.

400.—TEWKESBURY AND MALVERN.

Incorporated by 23 Vic., cap. 72 (25th May, 1860), to construct a line from the Ashchurch branch of the Midland to Great Malvern. Length, 14¼ miles. Capital, 145,000*l.* in 10*l.* shares; loans, 48,000*l.* Agreements with Midland. Opened from the Malvern junction with the West Midland to Malvern Hill station on 1st July, 1862, and throughout on 1st May, 1864.

By 25 and 26 Vic., cap. 56 (30th June, 1862), the company was empowered to raise additional capital to the extent of 120,000*l.* in shares, and 40,000*l.* on loan.

This undertaking continues in abeyance, no arrangement having yet been effected with the Midland.

No. of Directors—8; quorum, 3. *Qualification,* 500*l.*

DIRECTORS:

Chairman—DAVID JOSEPH HENRY, Esq., 55, Kensington Garden Square, W.

Bassett Smith, Esq.
Alfred Beeston, Esq., 4, Regent's Park Terrace, N.W.
Edward Harrison Barwell, Esq., Northampton.
John Edward Campbell Koch, Esq., 1, Threadneedle Street, E.C.

Robert F. Gordon, Esq., Belfast.
Timothy Kenrick, Esq., Edgbaston, Birmingham
William P. Price, Esq., M.P., Tibberton Court, Gloucester, and 105, Pall Mall, S.W.

OFFICERS.—Sec., Richard Stephens; Eng., George Willoughby Hemans, 1, Westminster Chambers, Victoria Street, S.W.; Auditor, E. Bellamy, 7, Victoria Chambers, Westminster, S.W.; Solicitors, S. F. Noyes, 1, Broad Sanctuary, Westminster, S.W., and Thomas Holland, Malvern.
Offices—

Above: LMS Timetable, October 1941.

Right: Bradshaw's *Railway Guide & Shareholders' Manual,* 1869.

The Halesowen Branch.

The Halesowen Branch

The first railway to Halesowen was a branch from Old Hill to Halesowen authorised in a West Midland Railway Additional Works Act of 17 July 1862. It was intended that a junction would be made at Halesowen with the projected Halesowen and Bromsgrove Railway. Henry Lovatt won the construction contract and used ex-Cambrian Railways 0-6-0ST No. 18 *Cardigan*. The line between Old Hill and Halesowen opened on 1 March 1878. Although a branch to Halesowen Basin was included in the original Act, powers lapsed before it could be built and the branch was eventually constructed under the GWR Act of 2 August 1898 and opened on 2 April 1902.

On 5 July 1865 an Act of Parliament authorised the Halesowen and Bromsgrove Railway to build a line connecting those two places and also construct a branch to the Midland Railway at Longbridge. Two of the directors and several of its officers were common to the Harborne Railway. Financial difficulties arose and on 1 August 1870 parliamentary powers were given to abandon the proposed line to Bromsgrove. It was still intended to proceed with the line to Longbridge, but no contractor was willing to make the necessary financial outlay. On 13 July 1876 an Act changed the name of the project to the Halesowen Railway. Construction work started soon after this date and the completed works were inspected by the Board of Trade in August 1881 and, after modifications, were passed in May 1882.

Due to a dispute between the GWR, MR and Halesowen Railway over works – the latter was supposed to construct at the MR's Northfield station – the single-track branch was not opened to passengers and goods, including Frankley public siding, until 10 September 1883. A celebratory public breakfast was held at the Shenstone Hotel on 1 October 1883. Under an agreement of 30 July 1872 the line was worked by the MR and GWR for 50 per cent of the gross receipts. In 1904 the company was declared bankrupt and following negotiations was vested jointly in the two companies on 1 July 1906.

Regular passenger services between Halesowen and Northfield were withdrawn in April 1919, and Old Hill to Halesowen was closed to passenger traffic on 5 December 1927, but workers' specials continued to use the branch platform at the Austin factory, Longbridge, for another forty years; a service from Old Hill to Longbridge was withdrawn on 1 September 1958 and New Street to Longbridge in January 1960. The line between Halesowen and Rubery closed completely on 6 January 1964, the last train being hauled by Class 2MT 2-6-0 No. 46505

1501 class 0-6-0PT No. 1524 with a train of four-wheeled coaches, probably on a workmen's service, near Halesowen, 29 May 1935. This engine was withdrawn in May 1939. *Colin Roberts collection*

A 2-4-0T at Halesowen, *c.* 1910, view towards Rubery. Notice the station garden which won several prizes around this date. *Author's collection*

on 4 January. Rubery to Longbridge closed on 6 July 1974 and services were withdrawn on the Old Hill to Halesowen and the Halesowen Canal branches on 9 September 1968 – though a traffic of ingots continued to run as required to Walter Somers Limited's premises opposite the goods shed. From Rubery a standard gauge, single-line branch was brought into action in 1897 for contractor Abram Kellett's use when building Frankley Reservoir. This temporary line closed around July 1904 on completion of the contract. Kellett used six 0-6-0STs, three named after local places: *Rubery, Frankley* and *Northfield*. This line was relaid with 2-foot-gauge track in 1924 to assist in the construction, by E. Nuttall, of Bartley Green Reservoir and was lifted in 1932. This narrow gauge line was worked by seventeen four-wheel petrol-mechanical locomotives.

Another temporary branch was that built from a junction between Longbridge and Rubery to assist in the construction of Hollymoor Asylum. The half-mile-long standard-gauge line was in place from 1901 to 1904 and worked by Manning Wardle 0-6-0ST *Hollymoor*, built in 1901.

The Halesowen branch left the Birmingham to Gloucester main line at Halesowen Junction immediately south of the present Longbridge station and climbed at 1 in 80 past the extensive sidings to the Austin Motor Works to which lines were first laid in 1915, (a workers' station opened in February 1915) and subsequently increased. The branch entered Worcestershire just before Rubery, not far from where the Hollymoor Asylum branch made a trailing junction.

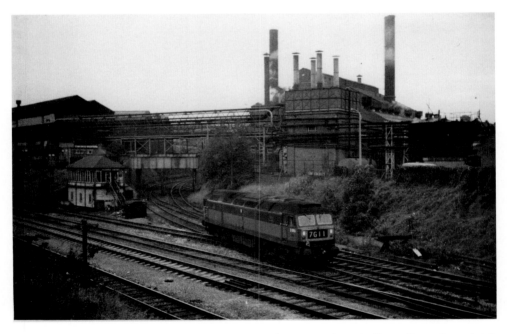

Class 47 No. D1915 at Longbridge Junction, 12 October 1966. The main line to Barnt Green is left and the Halesowen branch, right. *J. E. Cull/Colin Roberts collection*

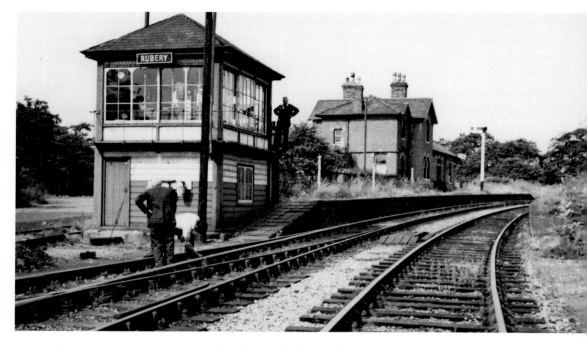

Rubery, *c.* 1955: view towards Hunnington. The Up platform is rather overgrown. Notice the MR pattern signal box and the GWR home signal. The permanent way staff are in attendance. *Lens of Sutton*

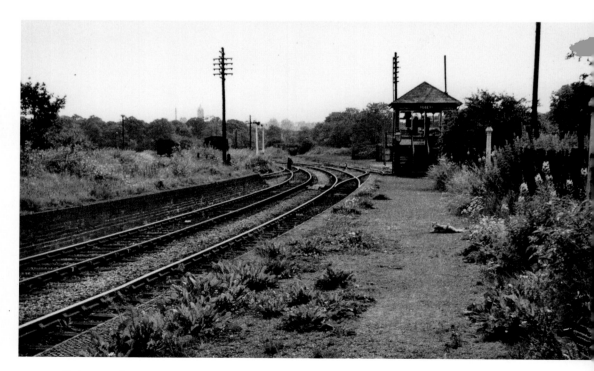

Rubery station, *c.* 1957: view towards Longbridge. *Author's collection*

Rubery, with a passing loop, had a brick-built station house with adjoining offices. For a mile beyond Rubery the climb continued at 1 in 60 and then descended at 1 in 50 past Frankley Sidings, where the ground frame and sidings were removed on 13 October 1957. The line crossed the impressive 234-yard-long, nine-span steel trestle Dowery Dell Viaduct. This structure was only able to support the weight of engines of the 2F power class, or below. It was dismantled in April 1965.

Hunnington had a single platform on the Down side, its brick building being similar to that on the Down platform at Rubery. The station closed to workmen on 1 September 1958. The yard had a goods shed, traffic including that for the Blue Bird Toffee works. The falling gradient of 1 in 50 continued to Halesowen. So far the branch stations were MR in character, but that at Halesowen was a GWR two-platformed affair, single storey in red brick. The passenger footbridge had stringers and landing supports made from old rails, and timber planking preventing careless passengers from falling through the lattices. Until the opening of the line through to Rubery, Halesowen had but one platform situated on the west, Up, side of the line. Subsequent to the opening of the extension, a Down platform was added, but the track layout was such that any through Down train could not use it without reversing, though through Up trains could use the Up platform. By 1904 the layout had been further modified to allow through running to each platform, while a central siding was provided for stabling locomotives or rolling stock.

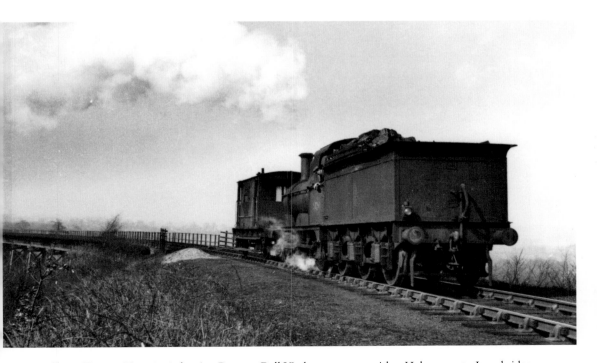

Class 2F 0-6-0 No. 58261 leaving Dowery Dell Viaduct, *c.* 1955, with a Halesowen to Longbridge train. *G. Bannister*

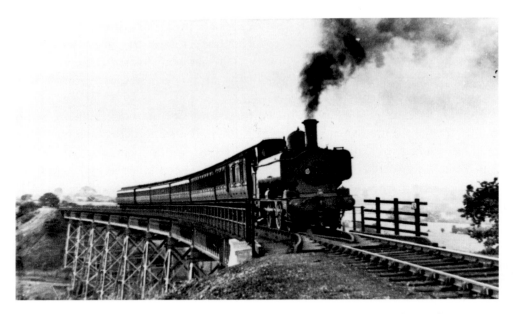

655 class 0-6-0PT No. 2718 crosses Dowery Dell Viaduct on 12 July 1939 with a workmen's train to Longbridge, comprised of clerestory stock. Notice the check rails designed to guide derailed stock onto the viaduct rather than letting it plunge down the embankment. *H. C. Casserley*

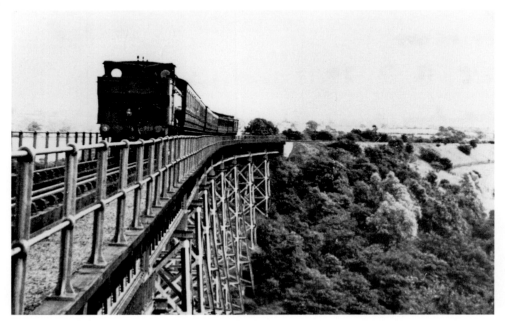

655 class 0-6-0PT No. 2718, with an open-backed cab, crosses Dowery Dell Viaduct on 12 July 1939. *H. C. Casserley*

From Canal Basin Junction at the far end of the goods yard, the Halesowen Basin branch curved eastwards and then southwards, almost making a circle back towards Halesowen passenger station. En route it served the three sidings at Coombswood Colliery, which were lifted around September 1937. The basin, with its nest of more than a dozen sidings in addition to those used for transfer between rail and canal (covered accommodation was provided), had private sidings serving several industries.

Coombes Holloway Halt opened on 1 July 1905 with the introduction of steam railmotors. Its timber platform, 150 feet long and 6 feet wide, with a corrugated iron pagoda, had a 1 in 5 inclined ramp giving access from Gorsby Road. In April 1913 the platform was moved from the east to the west side of the single line to allow the third side of a triangular junction to be built giving access to the canal basin. The new curve opened in 1914. This new junction was controlled by Halesowen Basin Junction signal-box situated immediately north of the halt. The halt closed on 5 December 1927 and the signal-box and new curve shut the same year. The line climbed at 1 in 70 and became level through the 151-yard-long Haden Hill Tunnel, rising at 1 in 50 out of Worcestershire to Old Hill.

MR passenger trains usually consisted of a Class 1P 0-4-4T and three coaches, two of which were six-wheelers. Most of the MR trains were 'mixed'. Until 1944 goods trains were worked by Kirtley double-framed 0-6-0s, but that year Johnson Class 2F 0-6-0s were introduced, the latter sometimes stalling on the 1 in 50 bank to Frankley. Bournville shed provided locomotives for branch working and had the last Kirtley 0-6-0, No. 58110, the only member of its class to carry a BR number. It was withdrawn in December 1951. MR and LMS locomotives only worked from the Midland main line to Halesowen, whereas GWR tank engines with workmen's trains worked through from Old Hill to Longbridge. In the latter part of the Second World War, two Johnson Class 3F 0-6-0s drew hospital trains from Longbridge Junction to Rubery, the nearest station to Hollymoor Hospital.

On 10 September 1883 the initial service was seven trains each way, four provided by the MR and three by the GWR. In August 1887 the GWR ran thirteen trains from Old Hill to Halesowen with one less in the reverse direction, trains taking five minutes for the journey. The service worked by the MR east of Halesowen was much less frequent, only five trains being run each way. They took twelve minutes to travel from Halesowen to Rubery and fifteen minutes in the reverse direction. Although some steam railmotors were introduced in March 1905, the full service with twenty-one return trips on weekdays and thirteen on Sundays did not commence until 1 July 1905. The Divisional Superintendent at Birmingham wrote to the local staff on 27 June urging them to find an advertiser to take up the empty space on the reverse of the tickets sold by the conductors. The charge was £1 10s 0d per 10,000 tickets.

By April 1910 the steam railmotors working the Old Hill to Halesowen shuttle service provided twenty-seven trains each way, the MR still running five trains on its section. This latter service was reduced during the First World War and

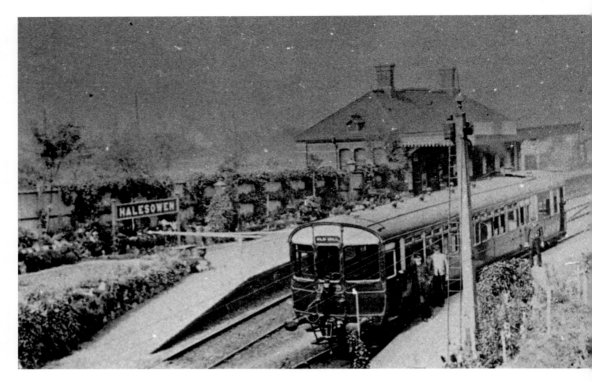

Steam railmotor No. 29 at Halesowen, *c.* 1905, with an Old Hill working. Built in January 1905, it was withdrawn in July 1919 for conversion to trailer No. 125. *Author's collection*

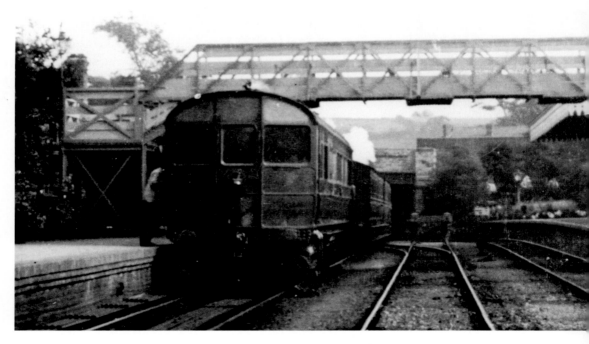

A steam railmotor at Halesowen, *c.* 1910, with a locomotive-hauled train beyond. *Lens of Sutton*

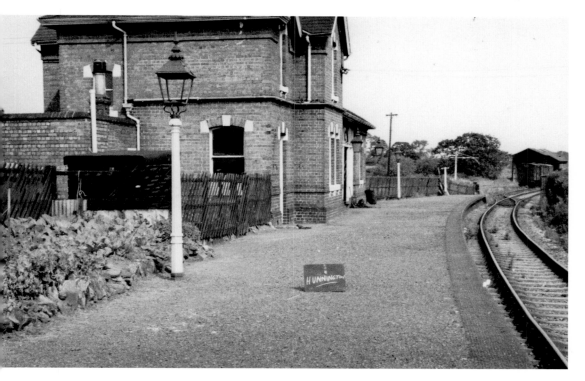

Hunnington, *c.* 1955: view towards Halesowen. Notice the goods shed in the distance on the right. *Lens of Sutton*

entirely withdrawn in April 1919. Until the Old Hill to Halesowen line closed to passengers on 5 December 1927, the railmotors made twenty-three trips each way. Unadvertised workmen's services ran until 31 March 1928. After the MR passenger services ceased in 1919, two through workmen's trains were run between Halesowen and Longbridge operated by GWR engines and crew. Until 1949 the WR used open-cab 17XX class 0-6-0PTs on these trains, but that year 74XX class 0-6-0PTs were introduced. Between Old Hill and Halesowen, and on the Basin branch, there were no serious weight restrictions and 57XX class 0-6-0PTs worked this section.

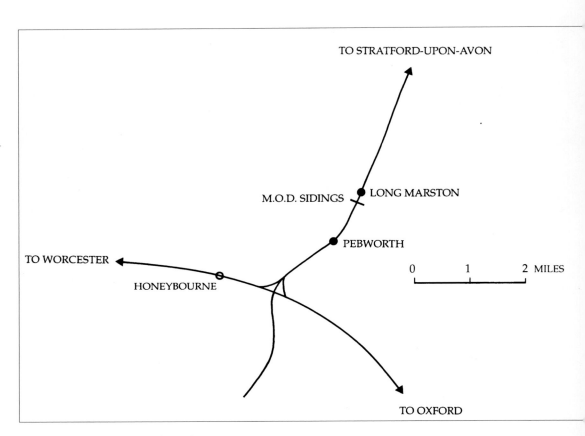

TO STRATFORD-UPON-AVON

M.O.D. SIDINGS ● LONG MARSTON

● PEBWORTH

TO WORCESTER

HONEYBOURNE

0 1 2 MILES

TO OXFORD

Honeybourne to Pebworth.

Honeybourne to Long Marston

The Oxford, Worcester and Wolverhampton Railway's branch to Stratford-upon-Avon from the main line at Honeybourne was authorised by Parliament on 27 July 1846, but due to the difficult state of the money market, the single-track standard gauge branch was not completed and opened until 12 July 1859, intermediate stations being at Long Marston and Milcote.

On 24 July 1861 the line was extended from its temporary terminus to the GWR's Hatton to Stratford branch, which resulted in through trains running between Leamington, Worcester and Malvern from 1 August 1861.

The GWR, which had taken over the OWWR, built a new line southwards from Honeybourne to Cheltenham and another north from Wilmcote to Tyseley, thus creating a new main line between Birmingham and Bristol. Doubling the branch from Honeybourne to Stratford was carried out by Messrs Walter Scott and Middleton, the Worcestershire section being completed on 28 April 1907. The branch became a main line when a service of express passenger trains began from Birmingham to Bristol on 1 July 1908, the fastest covering the distance of 98 miles in two hours thirty-five minutes. The only station on this line in Worcestershire was Broad Marston Halt, opened 17 October 1904 and closed on 14 July 1916. Pebworth Halt on the same site opened on 6 September 1937 and closed on 3 January 1966.

After the diversion of most inter-regional traffic by 8 November 1965, the line reverted to branch status, its only regular traffic being three freight and two parcels trains daily, following the withdrawal of the stopping passenger service on 3 January 1966. The line from Cheltenham to Honeybourne, and Long Marston to Stratford-upon-Avon was closed on 1 November 1976, leaving from Honeybourne to the Ministry of Defence depot at Long Marston as a long siding.

The junction station at Honeybourne has had quite a varied history. It opened on 4 June 1853 as a passing loop station on the single line from Oxford to Worcester. The track was then doubled either side of the loop on 20 March 1855, and with the opening of the Stratford-upon-Avon branch it became a junction on 12 July 1859. Its first station-master was Richard Bunn and he remained for over forty years, retiring in 1894 aged seventy.

Developing traffic on the Oxford to Worcester and the Birmingham to Cheltenham lines caused Honeybourne to become congested, so a new station

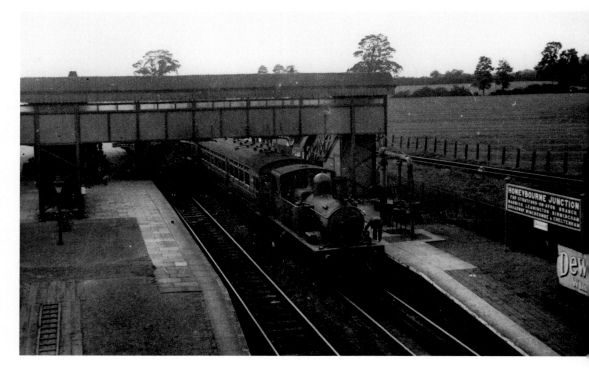

Honeybourne, view Down, *c.* 1938. A 0-4-2T heads an auto train, while a Down train is being loaded at the opposite platform. The comprehensive name board reads: 'Honeybourne Junction for Stratford-on-Avon branch, Warwick, Leamington, Birmingham, Broadway, Winchcombe & Cheltenham.' As was usual for the period, an advertisement for the *Daily Telegraph* hangs below the sign. *Lens of Sutton*

Intending passengers at Pebworth Halt faced a steep climb, March 1967. *D. J. Hyde*

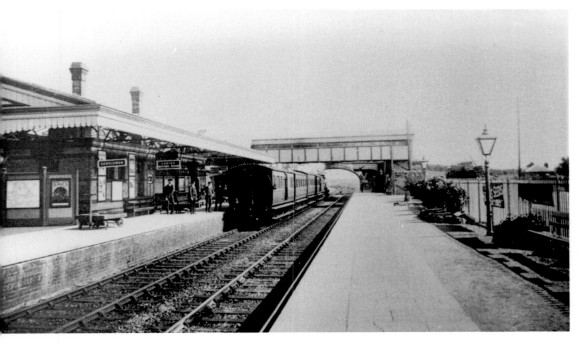

Honeybourne, view Up, *c.* 1905. A train of four six-wheel coaches is hauled by a 'Dean Goods' 0-6-0 engine. *Author's collection*

An Oxford to Worcester train drawn by a 2-4-0 passes Honeybourne West Loop during the construction of the Cheltenham to Honeybourne line in 1903. A contractor's 0-6-0ST is on the left. *Author's collection*

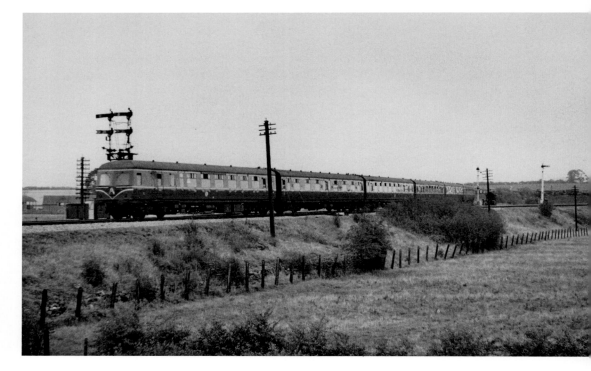

A six-car Swindon Inter-City DMU working the 12.25 p.m. Birmingham (Snow Hill) to Cardiff (General) on 23 September 1957, takes the north to west curve at Honeybourne to travel via Evesham and Ashchurch, due to the closure of the Honeybourne to Broadway and Cheltenham route for extensive permanent way works. *Michael Mensing*

was built in 1909. This had two platforms and a central island platform. The old station was lit by oil lamps, but the new was illuminated by acetylene gas. Wartime conditions, however, caused a shortage of carbide, so oil lights were re-introduced in 1917. Gas lighting was restored in 1928 and electricity used in 1942. Additional sidings were laid in 1924 to cope with the developing fruit traffic. Honeybourne closed to goods traffic on 1 June 1964 and to passengers on 4 May 1969. But this was not quite the end of the story, as the station was ceremonially re-opened on 22 May 1981 and to the public three days later. The first engine shed at Honeybourne was a single-road, brick-built affair, its site required for station improvements; it closed in 1907 and the 1909 replacement building burnt down on 13 September 1911. Never restored, engines remained in the open for fifty-four years until the depot closed in December 1965.

During the Second World War an infra-red lamp was set up in the centre of the triangular junction and used for bombing practice. This infra-red light marked film carried by a bomber and indicated whether the bomb would have been on target.

At first the branch was worked by tender engines, but from 1861 the line was worked by No. 68, later GWR No. 225, a Beyer, Peacock 2-4-0T. In the early

1880s 517 class 0-4-2Ts appeared. About 1905 steam railmotors took over some of the workings between Honeybourne and Stratford. In the later years of the GWR, the local services were covered by through Worcester and Evesham to Leamington or Birmingham workings handled by tender engines, 4-4-0 'Bulldogs' predominating until the early 1950s when they were replaced by 2251 class 0-6-0s, 43XX 2-6-0s, or more occasionally BR Standard Class 2 2-6-0s.

In August 1887 five Up and four Down trains ran on the branch. By April 1910 the service had improved to eight stopping trains each way, while the service immediately before closure was thirteen each way.

The Network Rail Great Western Route Utilisation Strategies published in March 2010 envisages reinstating some time in the future, an east to north chord at Honeybourne, which could see direct services from Paddington to Stratford-upon-Avon via Long Marston. It also mentions the very long-term possibility of re-assimilating the Stratford to Cheltenham line as a strategic freight route.

STRATFORD-UPON-AVON AND CHELTENHAM

MILCOTE

Warning Bell for Road Users of the Occupation Level Crossing at 6m. 17 ch. Near Milcote Station (Pearce's Crossing)

A warning bell is fixed at Pearce's Crossing, 530 yards on the Stratford-upon-Avon side of Milcote Station, indicating the approach of Up and Down trains.

The ringing of the bell will be actuated and discontinued by trains passing over independent treadles in the main lines.

LONG MARSTON

Working of East and West Ground Frames

The East Ground Frame, situated at the East end of the Exchange Sidings and controlling entrance to and from the Goods Yard and Down Main Line, is operated by the Shunter or Guard in accordance with standard instructions by Interlocking Lever at the Signal Box and Key Release Instrument at the Ground Frame.

The West Ground Frame, situated at the Honeybourne end of the Exchange Sidings, is operated in accordance with standard instructions by Interlocking Lever at the Signal Box and Key Release Instrument at the Ground Frame. The Ground Frame, which must only be operated by the Shunter, controls points and discs and signals connecting the Exchange Sidings with the Down Main Line and for movements over the shunting spur leading from the sidings at the Honeybourne end. When not in use the Ground Frame Cabin must be locked and the key kept in the possession of the Shunter.

Exchange Sidings

1. The exchange accommodation consists of five parallel sidings connected with the Main lines as shown below:—

Facing connection, Down Main to Sidings ⎫
Trailing connection, Up Main to Sidings ⎬ worked from the signal box.

Two trailing connections Sidings to Down Main, worked from the East and West Ground Frames.

2. The sidings are allocated for use as under:

Siding, in order from Down Main line	Holding Capacity exclusive of engine and van		Allocated to
	12-ton wagons	20-ton wagons.	
1	63	53	Reception road for trains.
2	63	53	Inwards wagons.
3	63	53	Outwards wagons.
4	64	54	⎰ Inwards or Outwards wagons
5	66	56	⎱ as required.
Spur	40	—	Shunting spur.

Sectional Appendix to the Working Timetable, October 1960.

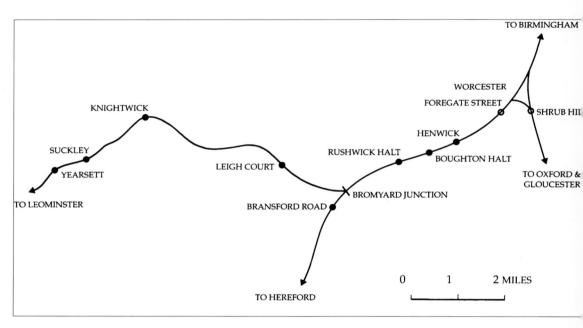

TO BIRMINGHAM

WORCESTER
FOREGATE STREET

SHRUB HILL

KNIGHTWICK

HENWICK

SUCKLEY

RUSHWICK HALT

BOUGHTON HALT

YEARSETT

LEIGH COURT

TO OXFORD &
GLOUCESTER

TO LEOMINSTER

BROMYARD JUNCTION

BRANSFORD ROAD

0 1 2 MILES

TO HEREFORD

Bromyard Junction to Suckley.

Bromyard Junction to Suckley

On 1 August 1861 an Act was passed for raising £200,000 to build a branch between Bransford Road, on the West Midland Railway's Worcester to Great Malvern line, and the Shrewsbury and Hereford Railway at Leominster. The WMR provided a quarter of the capital, but there was a certain amount of mismanagement, for on 31 March 1864 the company chairman, Sir Charles Hastings, and incidentally the founder of the British Medical Association, told the half yearly meeting that although £21,873 had been spent, not all the required land had been purchased, nor the building contract signed. On 7 October 1864 the shareholders were informed that the contract for building the Bransford to Bromyard section had been let to Yeoman of Darlaston and that work was progressing slowly. The company's engineers Wilson and Lewis reported in September 1865 that the works were 'in hand', but then on 22 December 1866 labour ceased, the contractor having been declared bankrupt. In January 1867 the contract was let to Jackson for completion. On 30 June 1867 the company's bank balance stood at only £67 and local inhabitants were invited to invest in the company in order that the line could be completed as far as Bromyard. The GWR stepped in with a loan of £40,000. In 1869 plans for carrying the line beyond Bromyard were abandoned and it was decided to make Yearsett, near Suckley and just over the border into Herefordshire, a temporary terminus.

Almost thirteen years after the Act was passed, the Board of Trade inspected the line on 29 April 1874 and granted a certificate. Bransford Road Junction (later named Leominster Junction) to Yearsett opened on Saturday 2 May 1874, intermediate stations being at Leigh Court and Knightwick. Suckley was not ready until 1 March 1878.

As powers had lapsed, an extension from Yearsett to Bromyard was authorised by an Act of 26 May 1873 and opened on 22 October 1877, Yearsett station being closed that day and the line diverted. The life of Yearsett station was one of the briefest on record. The Worcester, Bromyard and Leominster Railway Company was dissolved and sold to the GWR on 1 July 1888, ten shillings cash being offered for each £10 ordinary share. A new company eventually extended the line from Bromyard to Leominster, which opened on 1 September 1897, thirty-six years after it was first authorised. All stations on the branch closed to passengers and goods on 7 September 1964.

The branch curved westwards from the Worcester to Hereford line at Bromyard Junction signal-box. This was renamed Leominster Junction in the 1890s and

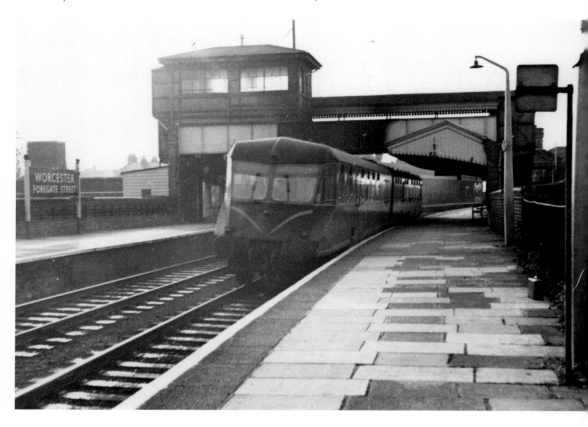

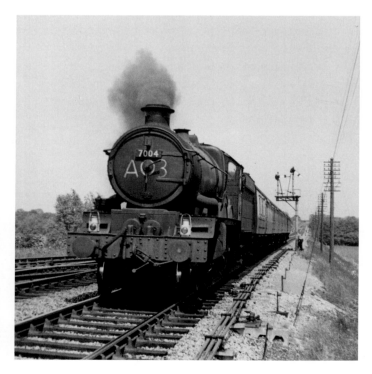

Above: Two ex-GWR diesel railcars, Nos W33W and W38W, joined by corridor connection and painted in BR green livery, stand at Worcester (Foregate Street) with a train from Bromyard, 4 November 1961. As the station is on a viaduct, the signal box necessarily had to be in this raised position. *E. Wilmshurst*

Left: 4-6-0 No. 7004 *Eastnor Castle* on 8 June 1963, works the 11.15 a.m. Paddington to Hereford express past Bransford Junction, where the branch from Bromyard is visible on the left. *Michael Mensing*

Bransford Road Junction on 25 September 1950. At this box Up trains for Worcester Tunnel Junction sounded one long and one short whistle. The branch was double for the first 286 yards in order to allow a Down train to pass an Up branch train held at the junction signals. The gradient rose at 1 in 162 from the junction to Leigh Court, a single-platformed, small, single-storey, brick-built station on the Down side. Its signal-box closed on 21 October 1956, when access to the single siding was governed by a ground frame.

Over a mile beyond the station, the branch crossed Hayley Dingle Viaduct, 107 yards in length and, nearly a mile beyond that, Broad Dingle Viaduct, 93 yards long. The gradient steepened to 1 in 100 up on the approach to Knightwick. This station, with a building in similar style to that at Leigh Court, also had a similar track layout, but by the 1920s an additional siding had been laid on the far side of the yard. Although Knightwick itself had a small population, the station was convenient for several hamlets and villages.

Suckley station had a timber-built office on its original single platform on the Up side and one siding. In April 1908 a crossing loop and Down platform, with a standard Great Western red-brick waiting hut, were brought into use. On 21 October 1956 the signal-box was closed and three new ground frames installed. The Down line was made a goods loop and the former Up line used for trains in both directions. The Up line was chosen because it offered a straight run.

Yearsett station was just over half a mile beyond and in 1953 its location could still be traced, the foundations of the buildings showing as well as the site of the

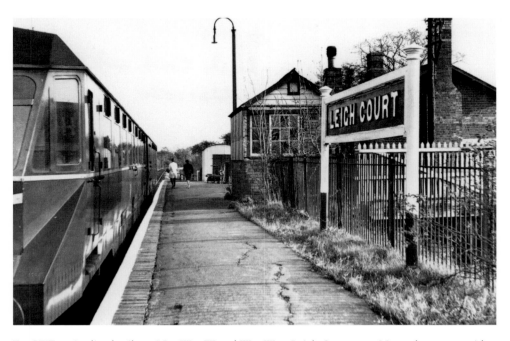

Ex-GWR twin-diesel railcars Nos W33W and W38W at Leigh Court on 4 November 1961, with a Bromyard to Worcester working. The signal box closed on 21 October 1956. *E. Wilmshurst*

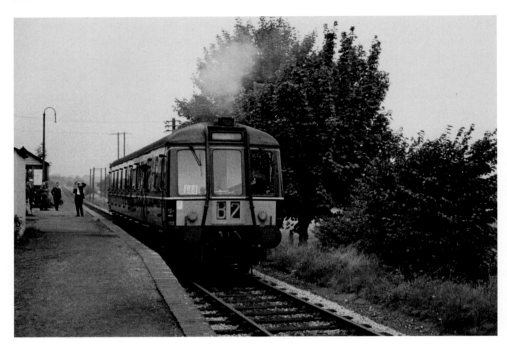

Gloucester Railway Carriage & Wagon Works Company motor brake second single-car DMU No. W55018 leaves Leigh Court on 5 September 1964 with the 17.17 Bromyard to Worcester on the last day of passenger working. Notice the neat arrangement of the exhaust pipes. *Michael Mensing*

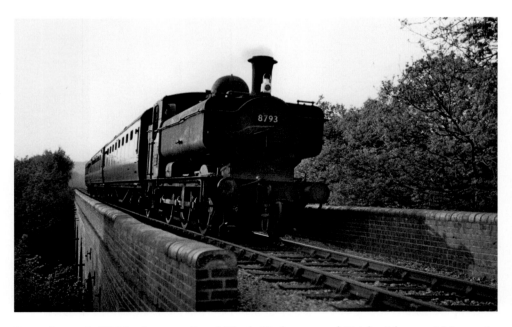

8750 class 0-6-0PT No. 8793 on Broad Dingle Viaduct east of Knightwick on 16 May 1964, working the 18.50 Bromyard to Worcester (Shrub Hill). The train comprises three corridor coaches. The shed plate, perhaps dirty, appears to be 65A (Eastfield, Glasgow), but actually is 85A Worcester. *Michael Mensing*

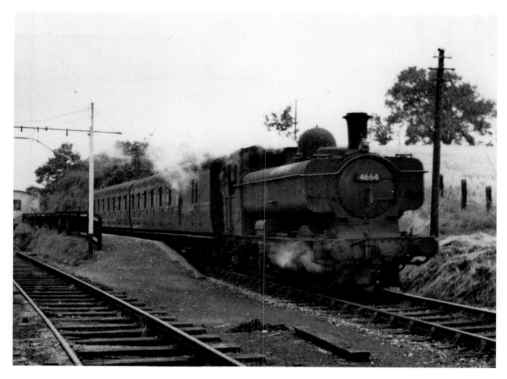

8750 class 0-6-0PT No. 4664 and a B-set leave Knightwick on 21 July 1956 with the morning train to Worcester. Notice the goods siding on the left and the loading gauge. *G. Bannister*

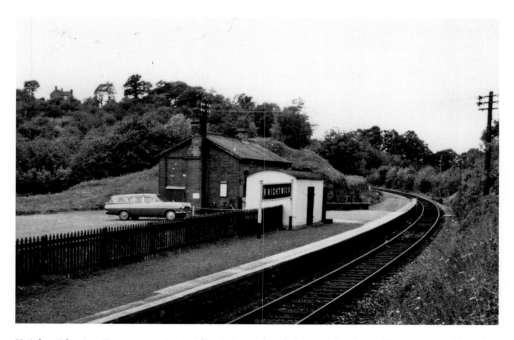

Knightwick, view Down, *c.* 1960. A siding is immediately beyond the fence. The corrugated iron hut is a lock-up for parcels, etc. Station lighting does not exist. *Lens of Sutton*

The luggage compartment doors of the twin ex-GWR diesels Nos 33W and W38W are open at Knightwick, 4 November 1961. *E. Wilmshurst*

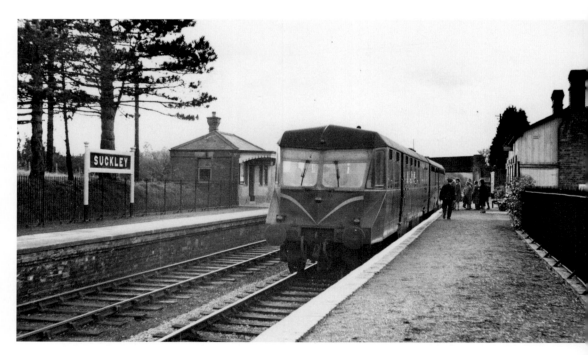

Ex-GWR twin-diesel units Nos W33W and W38W at Suckley with a train to Worcester, 4 November 1961. There is a startling absence of station lighting. *E. Wlmshurst*

buffer stops. It appeared to have been a single-line terminus with a run-round loop, end-loading dock and sidings. The former road entrance to the station yard had been replaced by a field gate with a small wicket adjoining, the short approach slope being still paved as originally constructed. The original line diverged from the later one half a mile west of Suckley station near milepost 131 and dropped away on a course partly covered by the embankment of the later line. In early days 517 class 0-4-2Ts worked passenger trains and 0-6-0STs headed goods. Latterly passenger trains were either worked by a 2-6-2T or 0-6-0PT and two-coach set or, from August 1934, an 0-4-2T and auto car. The 3571 class 0-4-2T No. 3574 appeared until it was withdrawn in 1949. A GWR diesel railcar was rostered on some workings. The 2251 class 0-6-0s tended to work goods trains. Because of the gradients, all Down freight and ballast trains, except those ballast trains completely fitted with vacuum brakes, were required to be worked wherever possible with a 20-ton brake van.

At the opening of the line to Yearsett in 1874 the four daily trains each way took thirty-five minutes from Worcester, a distance of 10¾ miles. One train each way was 'mixed'. A similar service was run when the line was extended to Bromyard. With the opening through to Leominster in 1897, five passenger and two goods trains ran each weekday, while a Sunday service from Worcester to Bromyard was introduced in 1923, running from May to October. In 1953 six trains ran from Worcester to Bromyard (the Leominster to Bromyard section having closed 15 September 1952), plus one goods train. When the remainder of the branch closed on 7 September 1964 there were only two trains from Worcester (Shrub Hill) to Bromyard, the first of the day leaving as late as 16.10, except on Saturdays when there were two extras, the first leaving at 10.20. Three trains ran in the opposite direction Mondays to Fridays and six on Saturdays. During the season hop-pickers specials were run, usually from Birmingham or the Black Country, the stock being 'third class coaches of the oldest type'.

Bradshaw's Railway Guide, August 1887.

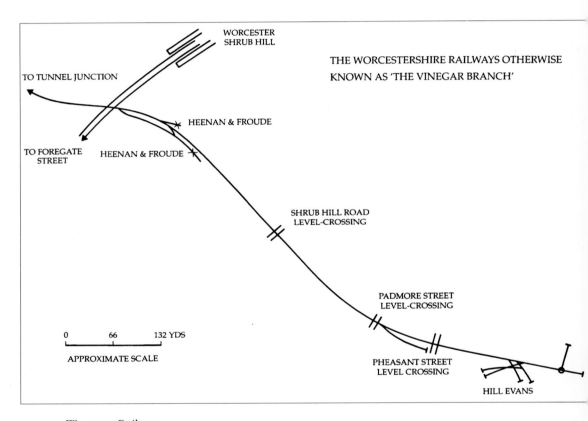

WORCESTER
SHRUB HILL

THE WORCESTERSHIRE RAILWAYS OTHERWISE
KNOWN AS 'THE VINEGAR BRANCH'

TO TUNNEL JUNCTION

HEENAN & FROUDE

TO FOREGATE
STREET

HEENAN & FROUDE

SHRUB HILL ROAD
LEVEL-CROSSING

PADMORE STREET
LEVEL-CROSSING

0 66 132 YDS

APPROXIMATE SCALE

PHEASANT STREET
LEVEL CROSSING

HILL EVANS

Worcester Railway.

Branches at Worcester

Worcester had a fascinating 900-yard-long, steeply-graded branch. The Lowesmoor Tramway, better known as the Vinegar Branch, was built under the Worcester Railways Act of 1 August 1870 and obtained by Hill, Evans and Company, vinegar manufacturers. The line, subject to a speed limit of 4 mph, opened in May or June 1872 and carried some 5,000 tons annually. A maintenance agreement with the GWR, was signed on 28 May 1872.

Other businesses used the line including Tower Nail Manufacturers; Worcester Engineering Works; Heenan & Froude and McKenzie & Holland – later taken over by the Westinghouse Brake & Signal Company.

Under the Act, the proprietors were obliged to provide signals at public road crossings to warn road users. Initially, slotted semaphore railway signals were used. There were no spectacle glasses, but lamps revolved on a vertical spindle in consonance with the signal arms. Each lamp was fitted with bull's eye lenses on four faces, presenting the appropriate colour to road traffic to correspond with the position of the signal arms. The signals were worked from a nearby lever, rod connections passing below the street. For the benefit of road users having time to read, notice boards explaining the purpose of these signals were fixed to the signal posts. In the 1930s the slotted posts were replaced by GWR tubular posts and ordinary enamelled lower quadrant arms. At the same time, the rod connections were abolished and replaced by a handle on a post, a key normally locking it in the 'Clear' position. Although general members of the public failed to understand these railway signals, to have abolished them would have required a repeal of the relevant clauses in the original Act of Parliament.

From Tunnel Junction the branch passed between the two engine sheds, then crossed the main line on the level between Shrub Hill Junction and Rainbow Hill Junction. Before the Shrub Hill Road level crossing were Messrs Heenan and Froude's private sidings. In addition to securely applying wagon brakes, sprags were required to be inserted in the wheels of any wagon left in the sidings, or if more than one wagon, sprags were to jam the wheels of vehicles at the lower end. To guard against runaways when shunting at these sidings, a brake van was required at the lower end of the vehicles on the branch line, as breakaways over busy level crossings could have had particularly serious consequences.

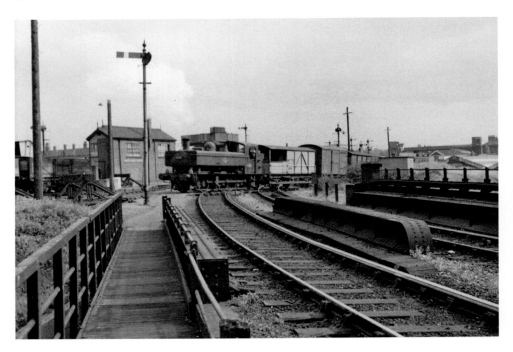

16XX class 0-6-0PT No. 1639 crosses the Shrub Hill to Foregate Street curve at Worcester as it leaves the 'Vinegar Branch' on 28 August 1962. The controlling signal box, Shrub Hill Junction, can be seen behind the locomotive carrying one white and one red headlamp. *Michael Mensing*

The termination of the former Vinegar Branch at the head of the gradient, 3 October 1965. Buffer stops render the notice 'All Down Goods & Mineral Trains Must Stop Dead here' superfluous. The vehicle on the right is accommodation van No. DW 234 for Motive Power Worcester, crane No. 9. *J. E. Cull/Colin Roberts collection*

A 0-6-0PT, probably a 1901 class, at the Shrub Hill Road level crossing, *c.* 1932. Notice the railway signals to control road traffic. *Author's collection*

The Sectional Appendix to the *Working Time Table and Books of Rules and Regulations for the Gloucester Traffic District* published in October 1960 gave the procedure to be followed at Shrub Hill Road level crossing:

(a) The Driver, after bringing the train to a stand at the fixed signal protecting Shrub Hill Road Level Crossing, must sound the engine whistle, which will be an intimation to the Crossing Keeper that the train is ready to proceed to Messrs. Hill Evans' works.

(b) The Shrub Hill Road Crossing Keeper must then operate the road signals in accordance with the following instructions:

Insert Key "X" in lock marked "X" on signal post on Shrub Hill side of road crossing, operate this key and place signal arm to Danger; hold the arm in this position by the metal handle, turn Key "Y" and withdraw it from the quadrant; take Key "Y" to the signal post on the Lowesmoor side of the road crossing, insert it in Lock "Y", operate the key, and place signal arm to Danger; hold the arm in this position by the metal handle, turn Key "Z" and withdraw it from the quadrant, Key "Z" is then available for releasing the Ground Frame locks on each side of the crossing.

(c) After the Ground Frame lock has been released and the appropriate signal lowered, the Shrub Hill Road Crossing Keeper must equip himself with flags, take up a suitable position in the public road, on the Shrub Hill Station side, and stop

the movement of all traffic (including pedestrians), over the crossing by exhibiting a red flag until the train has passed complete. The Crossing Keeper is responsible for exhibiting a green hand signal by flag to the Driver as an indication that road traffic has been stopped and the train may pass over the public road.

The signals referred to controlled road traffic at the ungated Shrub Hill Road level crossing and Padmore Street level crossing, the latter being in close proximity to the Midland Red bus garage. They were hand-operated and left clear until a train was about to cross. During the hours of darkness, fog or falling snow, the Shrub Hill Road crossing keeper was required to place on each side of the rails one lighted hurricane lamp with a red glass. He held a hand lamp, stood on the Shrub Hill station side of the crossing and stopped all traffic. The under-shunter assisted him.

The Sectional Appendix continued:

After the Shrub Hill Road Crossing Keeper has carried out his duties connected with the safe passage of a train over Shrub Hill Road, he must proceed to Padmore Street Road Crossing and ring the electric bell fixed on a post on the Shrub Hill side of the Padmore Street Crossing, as an indication to Messrs. Hill Evans & Company that the train is ready to enter the works.

(a) The hand points situated adjacent to Padmore Street Crossing are normally set and padlocked for entrance to the Vulcan Siding.

(b) The following method of working must be carried out:

Trains proceeding to Messrs. Hill Evans' works must be brought to a stand clear of the points on the Shrub Hill side of the Vulcan Siding. The engine must then be uncoupled by the Shunter and enter the Vulcan Siding, coming to a stand on Messrs. Hill Evans' side of Padmore Street Level Crossing; the points must then be reversed by the Shunter and the wagons gravitated into Messrs. Hill Evans' Works. (Whenever possible, the gravitation movement should be brought to a stand clear of Padmore Street Crossing so that the engine can be coupled up in the rear before the train fouls Pheasant Street Crossing).

During the time the engine is standing in the siding to permit of vehicles being gravitated towards the Vinegar Works, the Fireman must station himself near the hand point level and see that it is not moved until the whole of the vehicles have passed safely over the points.

Note – During gravitation, a brake van in which the Guard or Head Shunter must ride must be the leading vehicle owing to lack of clearance for staff to apply brakes to moving vehicles, and to ensure absolute control of wagons entering the firm's works.

(c) After the wagons have been gravitated clear of the Vulcan Siding connection, the engine must leave the Vulcan Siding and stand clear of the points until the Crossing Keeper has again set them in the required position. The Crossing Keeper must then take up his position on the public road, see all is clear, and hand signal the Driver to proceed.

(d) No movement of engine or wagons over Padmore Street Crossing must be made until an "All Right" hand signal or lamp has been received from the Crossing Keeper in charge of crossing.

Note – The Vulcan Siding hand points must be unlocked by the Shrub Hill Road Crossing Keeper after the train has come to a stand; this man is also responsible for setting the hand points for the siding and locking them in that position as soon as practicable after the train has returned from the works and passed to Worcester Yard, and for the safe custody of the key of the padlock.

(e) The Shrub Hill Road Crossing Keeper is responsible for the protection of Padmore Street Level Crossing for the passage of Down trains during clear weather, or when fog or falling snow prevails, in precisely the same manner as for the

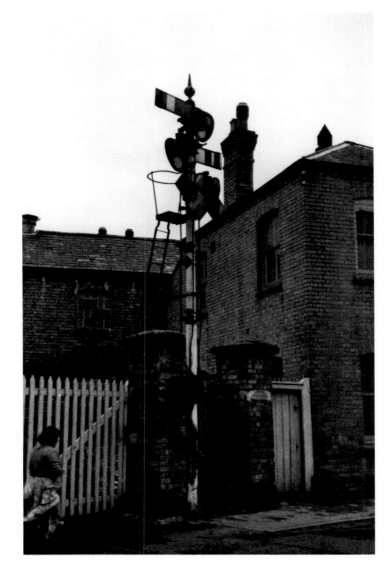

Semaphore signals for road and rail on the same post at Pheasant Street level crossing, 20 November 1959. *J. E. Cull/Colin Roberts collection*

protection of Shrub Hill Road Crossing; before signalling any movement which necessitates an engine or vehicles passing over Pheasant Street Crossing, he must satisfy himself that the appropriate fixed signal at Pheasant Street Crossing has been lowered for the movement of wagons or engine across the public highway to enter the premises of Hill Evans & Company.

Messrs. Hill Evans provide a man at Pheasant Street Public Road Level Crossing to control traffic and he will be equipped with the necessary flags and hurricane lamps with red glasses for stopping road traffic. The fixed signals situated on the Worcester (Shrub Hill) side of the crossing are operated by this man. No movement of engine or wagons on to or over the public highway must take place without the engine whistle being sounded and the Driver receiving a green hand signal by flag or lamp from the man protecting the crossing indicating the engine may pass on to or over the public road; in addition the Driver must satisfy himself the appropriate fixed signal has been lowered.

Messrs Hill Evans made shunts in their sidings with a tractor. When a train was ready to leave the vinegar works, the engine driver sounded two whistles to intimate to the Shrub Hill Road crossing keeper that it was ready to leave for Worcester Yard. On the return journey both brake vans were to be at the rear to guard against any breakaways. On both Down and Up journeys a man, that is the guard or under-shunter, was to ride in each van, except during fog or falling snow, when the latter was required to assist the Shrub Hill Road Crossing Keeper. In any weather, care was to be exercised to ensure that the crossing keeper was in position to avoid a train being stopped on the steep incline between the works and Padmore Street except in a case of emergency. Up trains were required to be brought to a stand before Shrub Hill Road level crossing and procedure there was as for trains in the opposite direction.

Regarding Hill Evans' employees, the Appendix instructed that on receipt of a gong intimation from the Shrub Hill Road crossing keeper, the Hill Evans' man should open the gates of Padmore Street level crossing and return to Pheasant Street to control traffic over the public highway while the train was passing. The road signal was required to be placed at danger, and when the traffic had been brought to a stand he was to lower the railway signal.

Signals on the branch could not be treated as normal railway signals because an engine driver was not to move forward from a signal protecting a crossing after it had been lowered until he received an 'All Right' green hand signal from the crossing keeper indicating that the public highway was clear for the passage of the train. The maximum load for the branch was twelve vehicles, subject to the gross weight of the twelve vehicles not exceeding 104 tons exclusive of the two brake vans. The GWR-type of brake van was preferred as it was equipped with sanders. The head shunter travelled in the leading van and the under-shunter in the rear van.

The Appendix stated that it was very important that trips to and from the Worcester Railways worked to schedule and unless special instructions were

issued, shunters were not waiting at the various works for traffic which was not ready. A return trip took about forty-five minutes. The branch subject to a weight restriction was often worked by 850 class 0-6-0PT No. 2007 and more recently by 16XX class engines of the same wheel arrangement. A 204 hp 03 class 0-6-0 was tried and proved hopeless. The line was last used on 5 June 1964.

The single line staff with keys to operate the points, was kept in Shrub Hill signal box. The Tower Manufacturing Company's siding was on a very severe curve, so a locomotive was not allowed to enter. The curve was so sharp that wagons could not buffer up and couple. This meant using the expedient of placing a shunting pole through both sets of coupling chains and leaving it there until straight track was reached and the coupling could be thrown over the hook.

Should the rails be damp and the engine have a full load, sometimes an assistant engine was requested. If a heavier 0-6-0PT was the only engine available, the engine had to try to draw its load over the canal bridge which the heavier engine was not allowed to cross. The alternative was to divide the train and leave one brake van and the second half of the train to be collected after disposal of the first half.

Another Worcester line was the Butts and Riverside branch. It trailed from the Hereford to Worcester main line at Butts Branch junction and descended the 553-yard-long Butts Branch Viaduct alongside the 935-yard Worcester Viaduct

A lifting bridge on the Vinegar Branch, 17 November 1959. *J. E. Cull/Colin Roberts collection*

Left: The formation of the Butts and Riverside branch seen on 6 February 1965, descending alongside the Worcester Viaduct. *J. E. Cull/Colin Roberts collection*

Below: The Worcester to Hereford main line crosses the River Severn, while on the left bank is the riverside branch. Two low-sided wagons stand below the bridge, while a van and more open wagons are beyond, *c.* 1905. *Author's collection*

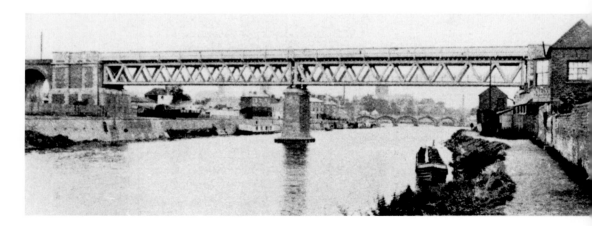

carrying the main line across both the valley and the River Severn. The branch then curved northwards alongside the river bank to Butts Terminus adjacent to the racecourse Grandstand Hotel. From Butts Terminus trains could reverse under the main-line Worcester Viaduct and then pass for almost half a mile along the North and South quays to Riverside Terminus. Originally used for rail/river exchange, the quay lines were closed about 1930. However, the line to Butts Terminus remained open and in the early 1940s was worked by LNER J25 0-6-0s No. 1989 and No. 2040, which were on loan to the GWR. Racehorse facilities were withdrawn on 25 April 1953 and the branch was last used in 1955. It was officially closed on 1 February 1957.

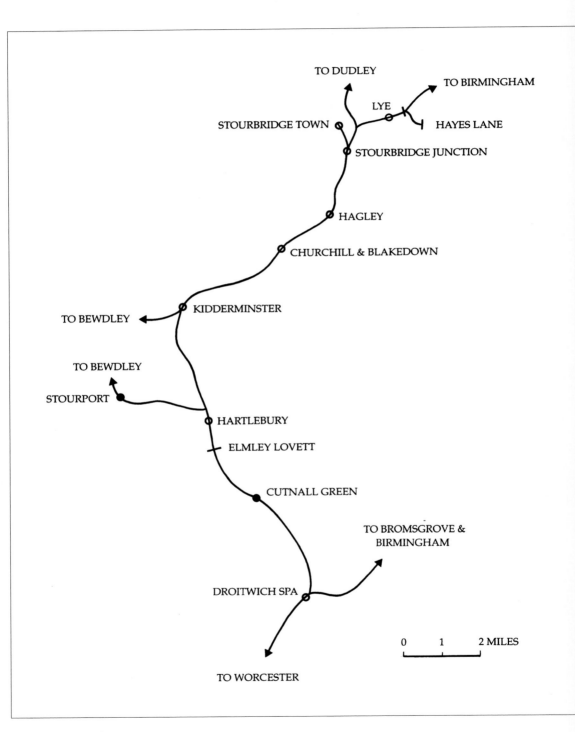

TO DUDLEY

TO BIRMINGHAM

LYE

STOURBRIDGE TOWN

HAYES LANE

STOURBRIDGE JUNCTION

HAGLEY

CHURCHILL & BLAKEDOWN

TO BEWDLEY

KIDDERMINSTER

TO BEWDLEY

STOURPORT

HARTLEBURY

ELMLEY LOVETT

CUTNALL GREEN

TO BROMSGROVE &
BIRMINGHAM

DROITWICH SPA

0 1 2 MILES

TO WORCESTER

Droitwich Spa to Lye.

Droitwich Spa to Lye

The Droitwich to Lye section of the Worcester to Birmingham line started as a main line, but was later relegated to branch status. The Oxford, Worcester and Wolverhampton Act of 4 August 1845 authorised the construction of a line from Wolvercot Junction – Oxford via Evesham, Worcester and Kidderminster – to the London and North Western Railway at Bushbury. The standard gauge line between Droitwich and Stourbridge opened on 1 May 1852, when the first train headed by 'A' (at first OWWR engines were lettered instead of numbered), a 2-4-0 hauling twenty-one coaches, left Stourbridge cheered by crowds, cannons and church bells, it was grandly welcomed at the other stations en route to Evesham. Stourbridge to Dudley opened to goods traffic on 16 November 1852 and to passengers on 20 December. Through trains began running between Dudley and Oxford on 4 June 1853 and from Wolverhampton on 1 July 1854.

On 14 June 1860 an Act was obtained for constructing the Stourbridge Railway from Stourbridge through Lye to Old Hill. The following year an agreement to work the Stourbridge Railway on its completion was made with the West Midland Railway, which had been formed from the amalgamation of the OWWR and two other companies. Stourbridge Junction to Lye and Cradley was opened on 1 April 1863, just four months before the GWR took over the WHR. An unfortunate event occurred in 1870 when, following the disappearance of the Stourbridge Railway's secretary and superintendent W. T. Adcock, it was discovered that he had issued false stock to the value of £52,000. From 1 February 1870 the Stourbridge Railway was vested in the GWR.

The LNWR's route to Birmingham was 113 miles, which the fastest expresses covered in two hours, but the GWR's route via Oxford was 129¼ miles and its best train needed two hours twenty-five minutes. On 1 July 1910 the GWR opened a new route to Birmingham via Bicester, and the distance of only 110½ miles allowed it to compete with the LNWR by also running expresses in two hours. From this date most expresses were diverted to the new line, Worcester to Wolverhampton becoming more of a branch and less main line in character.

Droitwich station opened on 18 February 1852, with the Worcester to Stoke Works Junction section first used only by the Midland Railway when some of its Gloucester to Birmingham expresses were diverted to serve Worcester, regaining their own metals at Stoke Works Junction. From 1 May 1852 OWWR trains used the Worcester to Droitwich section when the Droitwich to Stourbridge line

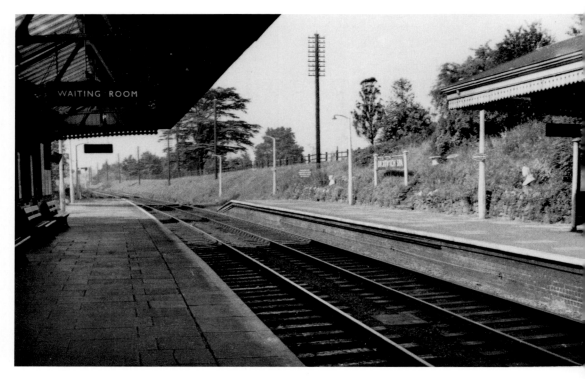

Droitwich Spa, view Up, *c.* 1960. The running-in board is illuminated by two lights. Unusually two busts are displayed in the station garden. *Lens of Sutton*

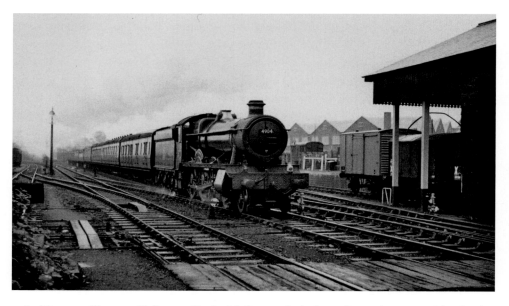

4-6-0 No. 4904 *Binnegar Hall* passes Droitwich Spa goods shed on 9 September 1956 with a Sunday excursion to Cardiff. Notice the barrow crossing in the foreground formed from old sleepers, and the signal box behind the last coach adjacent to the Stoke Works Junction line. *Michael Mensing*

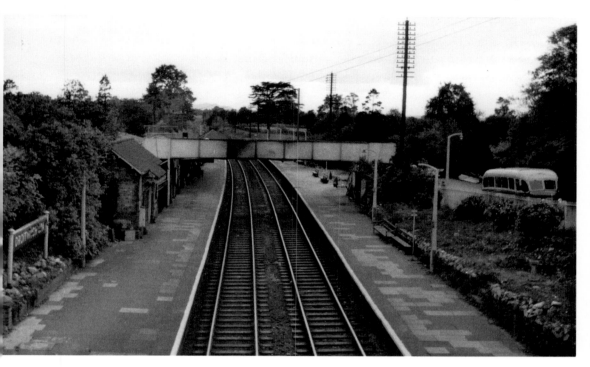

Droitwich Spa, view Up, 27 September 1964. The roof over the footbridge has been recently removed. A Bedford coach is on the right. *J. E. Cull/Colin Roberts collection*

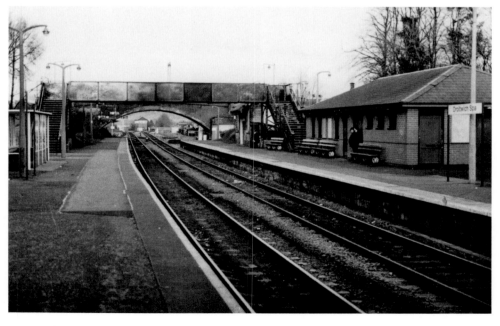

Droitwich Spa, view down, 5 February 1994. Beyond the very wide arch, lines to Birmingham bifurcate – via Kidderminster left and via Bromsgrove right. *Author*

opened on that date and Droitwich developed exchange of goods traffic with the MR. When Droitwich station was rebuilt in 1899, easy approaches were made to assist disabled people visiting the natural brine baths. The statues, urns and rustic work on the platforms were probably unique on the GWR. On 1 October 1923 the station was renamed Droitwich Spa. The Down platform was shortened in September 1966 and in July 1975 both platforms were shortened. Today there is a new red-brick office building on the Up platform. The goods shed was extended in 1905 but closed on 2 January 1967. The Stoke Works and Stourbridge lines divide just north of the station and beyond the junction are Berry Hill Sidings.

Cutnall Green Halt opened in June 1928. The platforms measuring 100 feet by 8 feet were economically made with dirt piled behind a sleeper wall, the waiting sheds being of corrugated iron. Adjacent was an Up mileage siding with a coal wharf and weighbridge, and in addition a refuge siding was provided for each of the main lines. The station closed to goods on 3 February 1964, and to passengers on 5 April 1965. At Elmley Lovatt an Up loop was opened on 6 November 1937, into which trailed Air Ministry sidings. The cost of £9,480 was paid by the Ministry.

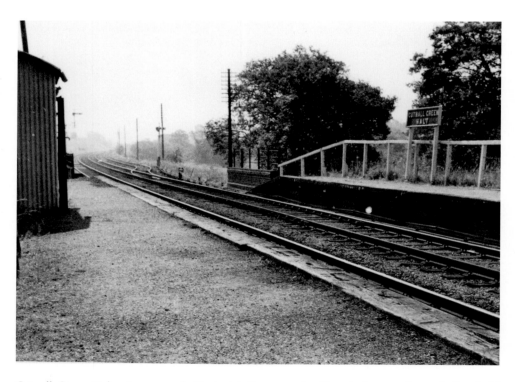

Cutnall Green Halt, view towards Droitwich Spa, *c.* 1960. The platform wall was built of old sleepers, then soil was tipped behind and topped with gravel. The Down refuge siding can be seen on the right. *Lens of Sutton*

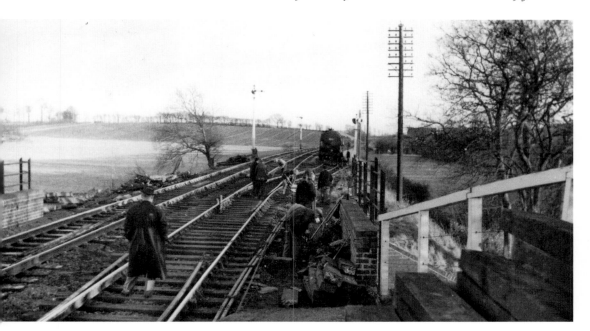

Cutnall Green Halt, view Up, 14 January 1962. Derailed tankers have caused permanent way problems. The sleepers on the right are replacements for those damaged. *J. E. Cull/Colin Roberts collection*

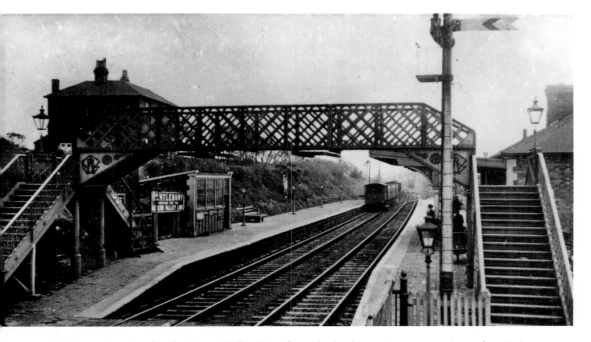

Hartlebury, Junction for the Severn Valley Line, from the level crossing, *c.* 1930. A goods train is on the Up line. Notice that the footbridge can be used by public and passengers alike. The waiting shelter on the left has an unusually large window. The GWR monogram appears on both sides of the footbridge. *Lens of Sutton*

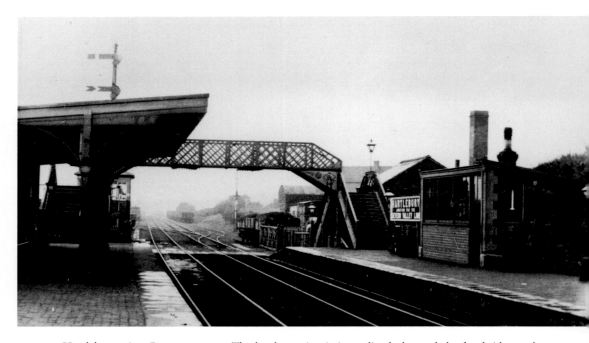

Hartlebury, view Down, *c.* 1905. The level crossing is immediately beyond the footbridge and a horsebox stands in the siding on the far right. A wheel at the top of the signal post is for lowering the lamp. The distant signal arm is painted red. The signal box has an 'S' plate showing, a red letter on a white ground, to indicate to a linesman a faulty signalling apparatus. *Author's collection*

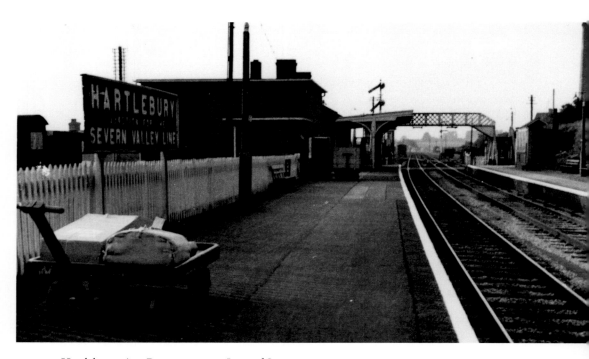

Hartlebury, view Down, *c.* 1960. *Lens of Sutton*

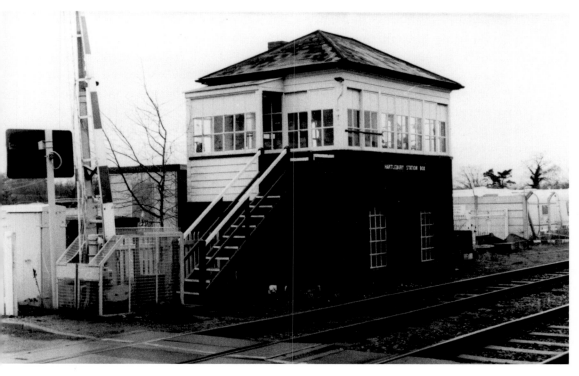

Hartlebury Station signal box, 5 February 1994. Signalman-controlled barriers have replaced the gates. *Author*

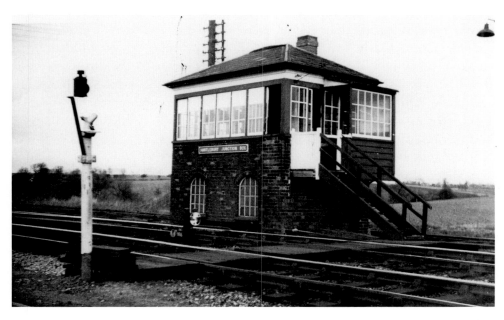

Hartlebury Junction signal box, pictured here on 3 February 1968, is almost a mirror image of the Station signal box, the only difference being fewer panes on the ground floor windows. Notice, left, the lamp illuminating the token pick-up. *D. Payne*

Hartlebury station was the junction with the Severn Valley line, the physical junction being situated about quarter of a mile north of the passenger station. The brick station building is situated on the Down side while the opposite platform had a brick-built waiting hut with an unusually large window. It was sensibly placed near the bottom of the footbridge so that passengers did not have to walk far. This footbridge at the Kidderminster end of the platform had steps to and from the roadway, as well as from the platforms, and so could be used by pedestrians when the level crossing gates were closed across the road. In 1910 the station was equipped with gas lighting at a cost of £300. A locomotive turntable on the north side of the level crossing was removed by 1922. In 1923 the goods yard had a second-hand weighbridge from Abersychan, north of Pontypool, installed at a cost of £140, and a 5-ton hand crane costing £125 came from Yeovil (Pen Mill). In 1924 two cattle pens were erected for £395. The same year, increased traffic in fruit demanded additional sidings at a cost of £4,350 and in 1942 a new goods office was built for £1,018.

Each day three to four coal trains were worked to Hartlebury by LMR locomotives, left in the sidings and 'tripped' to Stourport Power Station by a WR engine. The station closed to goods on 1 February 1965, and from 5 January 1970 lost its Severn Valley passenger traffic when these services were withdrawn. The locking frame in the station signal-box was taken out of commission on 7 November 1982 and a replacement miniature panel substituted from 28 November 1982 to control the crossing's lifting barrier.

Approaching Kidderminster, the line crosses the 371-yard-long Hoobrook Viaduct. Originally built of timber, it was replaced in the 1880s with blue brick arches built alongside the original piers. At its far end were Up and Down running loops which came into use on 16 December 1937. Kidderminster Junction signal-box, situated at the junction of the line to the engine shed and Bewdley, was demolished by a derailment in June 1953 and a temporary box was in use until 25 October 1953, when a permanent replacement was opened. Kidderminster was an important rail centre with nests of goods sidings, both BR and private, wagon repair sidings and carriage sidings. The station signal-box, renewed only on 16 December 1967, closed on 15 July 1973.

As Kidderminster was such an important traffic centre, the LMS siphoned off some of this by collecting carpets from the factory, then transferring them to an LMS barge for a canal journey to Wolverhampton, where they were transhipped to rail for the last leg of the journey to station or port.

The station building at Kidderminster was a very picturesque half-timbered structure, but dry rot caused it to be demolished and replaced by a single-storey red brick and glass box. Its only saving grace is the cobbled approach road shared with the splendid SVR station. The first Kidderminster station caught fire and it is believed that the half-timbered building was really destined for Stratford-upon-Avon, but the fire caused the set of prefabricated parts to be sent to Kidderminster instead.

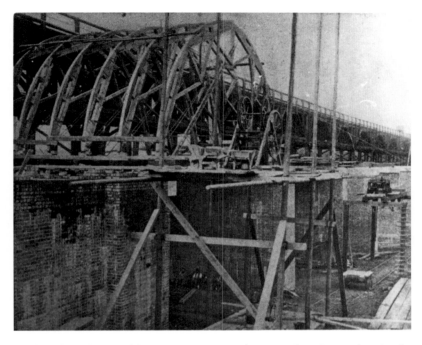

Hoobrook Viaduct, Kidderminster, *c.* 1882. The original timber viaduct in the background is being replaced by a brick structure. *Author's collection*

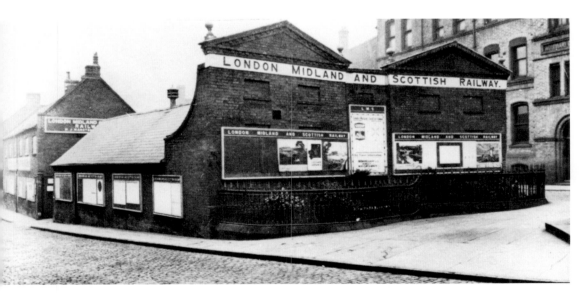

The fact that the LMS lacked a line to Kidderminster did not deter it seeking traffic – it had this goods receiving office, viewed here in around 1930. *Author's collection*

Carpets for export are being loaded onto an LMS barge, *c.* 1935, for a canal journey to Wolverhampton where they will be transferred to rail for the journey to a port. They have been brought to this wharf by an LMS Scammell mechanical horse and trailer, which can just be seen on the right. The LMS boatage depot is in the background. *Author's collection*

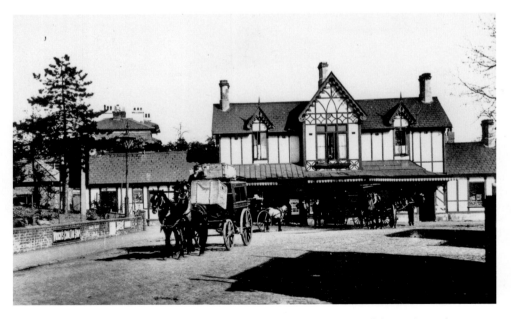

The attractive exterior of the station at Kidderminster, *c.* 1900. The small horse-drawn bus carries two large boxes. *Author's collection*

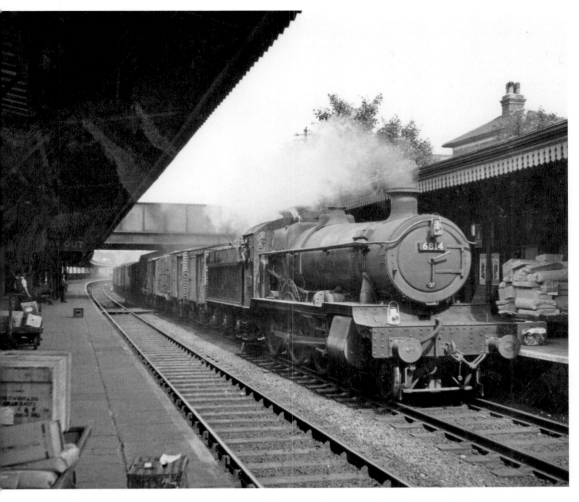

4-6-0 No. 6814 *Enborne Grange* (82B, St Philip's Marsh), passes through Kidderminster on 30 August 1962 with an Up fitted freight. *Michael Mensing*

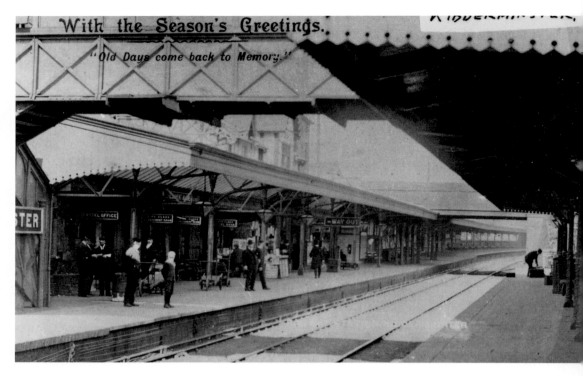

Kidderminster, view Down, *c.* 1905. The platform has been extended beyond the overbridge. Notice the glass in the platform canopy gives an airy appearance to the area below. Over the first door is the sign 'Third Class Refreshment Room' and over the next door the sign declares '1st & 2nd Class Refreshment Room'. The photograph appears to have been intended as a Christmas card. *Lens of Sutton*

The exterior of the replacement building at Kidderminster, 5 February 1994. *Author*

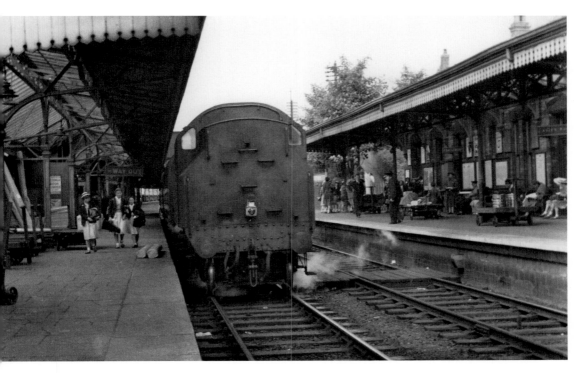

Kidderminster, view Down, *c.* 1960, showing the bunker of a BR Standard Class 3 2-6-2T. Notice the porters' walkway between the platforms. Schoolgirls are on both platforms. *Lens of Sutton*

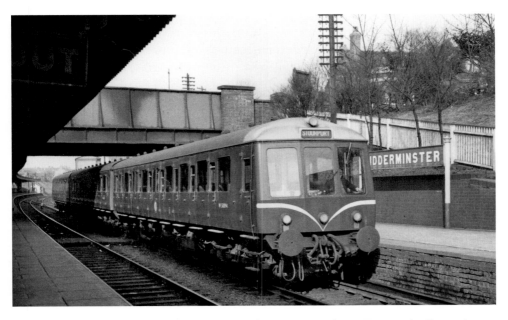

Derby Works-built three-car Suburban DMU with motor second No. W50094 leading arrives at Kidderminster with the 1.55 p.m. Birmingham (Snow Hill) to Stourport-on-Severn, Sunday 30 March 1958. *Michael Mensing*

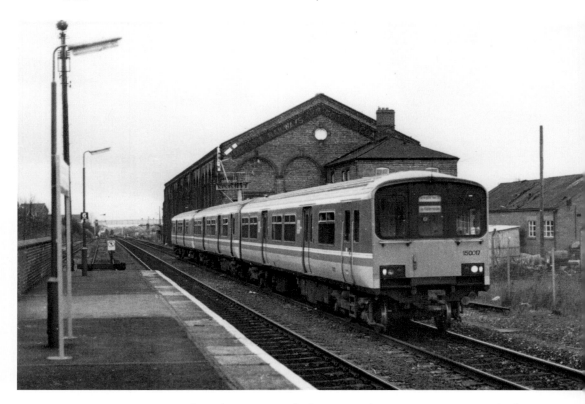

Sprinter No. 150 017 working the 12.28 Hereford to Birmingham (New Street) passes the former goods shed at Kidderminster, 5 February 1994. *Author*

The first engine shed at Kidderminster was of timber construction, had a single road and opened in September 1852. Situated south-east of the passenger platform, by 1926 it was inadequate for its allocation of eighteen locomotives. Thus in 1932 it was replaced by a new shed, funds for which were provided under the Loans and Guarantees Act of 1929, in order to help relieve unemployment. Preparation of the new site involved the removal of 10,000 tons of sand which was sent to the GWR works at Swindon, Wolverhampton and Caerphilly. The new 200-foot-long double-road shed situated south of the branch to Bewdley consisted of a steel frame clad with corrugated iron sheeting. However, it was not new, but came from Bassaleg where it had been the principal depot of the Brecon and Merthyr Railway. Built in 1921, the GWR closed it on 31 March 1929 as an economy measure subsequent to the 1923 Amalgamation. The shed had the GWR code KDR, while in BR times it was 85D from 1949 to 1960, 84G from 1960 to 1963 and 2P from 1963 to 1964.

The depot generally had a stud of one or two tender engines, but most were of the tank variety, some for goods and some for passenger working. In the late 1920s one of the latter was No. 27, an ex-Midland and South Western Junction Railway 4-4-4T. In May 1947 ex-Alexandra Docks Railway 2-6-2T No. 1206

was loaned to Kidderminster to work trains to the local sugar beet factory. On 31 December 1947 sixteen locomotives were allocated, and fifteen in March 1959. The shed closed on 10 August 1964, when its remaining engines were transferred to Stourbridge Junction.

Just before Churchill and Blakedown, now simply Blakedown, the line crosses the 173-yard Blakedown Viaduct, originally timber, but replaced in engineer's blue brick in the 1880s. Today on the Up platform is a GWR nameboard surrounded by attractive-looking shrubs. The original station building at Churchill and Blakedown was timber, later superseded by a standard GWR red brick building on the Up platform. Today it has just simple modern shelters. Hagley too, originally timber, was replaced by a GWR red-brick building on the Up platform, with a waiting room in the same style on the opposite platform. The covered footbridge is dated 1884. North of the station, the line passes through a long cutting of Old Red Sandstone.

The original station at Stourbridge, (it did not receive the Junction appellation until 1 October 1879), was situated between the junction of the branch to Stourbridge Town and the branch to Handsworth Junction. With the development of traffic, a new station was required, but this was impossible in such a cramped site. In March 1897 the GWR decided to build a new station half a mile to the south at the far end of the extensive goods yard.

The original station had only two platforms, but the new junction station opened on 1 October 1901 had two island platforms, allowing four trains to use them. Today the layout has been rationalised to give platforms for Up and Down Main and for the branch line, but the station buildings are substantially unaltered, apart from heavy-looking new roofs to the platform canopies. The opening of this new station caused the branch to be re-aligned so that it curved south instead of north to join the main line. This new route was used from the date of the opening of the new station. Together with the new passenger station, goods and livestock accommodation at Stourbridge Junction was improved and a goods line laid avoiding the passenger station.

At the north end of the goods sidings the original line to Wolverhampton, now the freight line to Dudley, curves left while the Stourbridge Railway carries straight on and proceeds to Lye. There the two-road, GWR standard red-brick station had a waiting shelter on the Down platform. Today the offices are contained in a modern flat-roofed building on the Up platform quite lacking in character. At one time Lye had a large goods shed, with the yard equipped with a modern travelling crane, and there were brickworks sidings at both ends of the station.

Hayes Lane Junction signal-box, situated over a quarter of a mile beyond Lye passenger station, closed in November 1887, the actual junction being moved nearer the station so that it could be worked from Lye signal-box. From its opening in June 1863, the three-quarters of a mile Hayes Lane branch curved southwards to serve several collieries and brickworks. Most of the branch closed in April 1962 and the remaining stub on 10 August 1964.

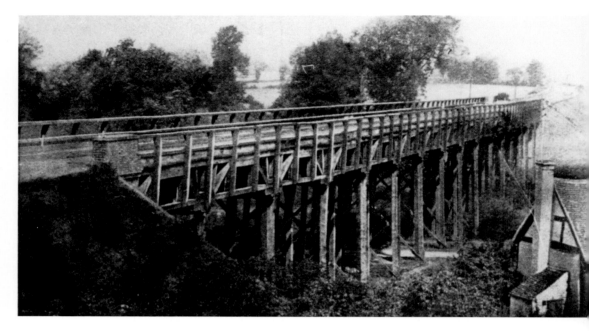

The 173-yard-long Blakedown Viaduct in 1877, a few years before it was replaced in brick. *Author's collection*

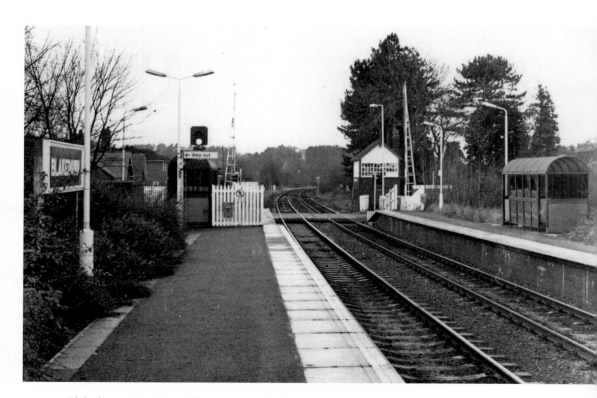

Blakedown, view Up, 5 February 1994. *Author*

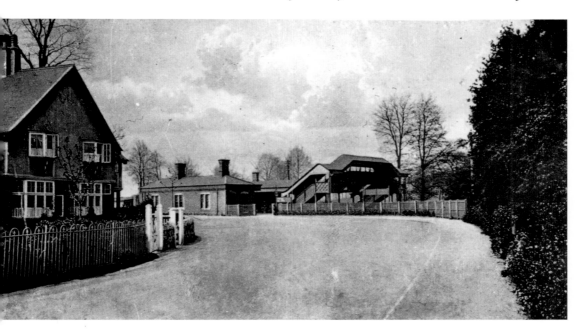

The attractive approach to the Up platform of Hagley station, *c.* 1920. *Author's collection*

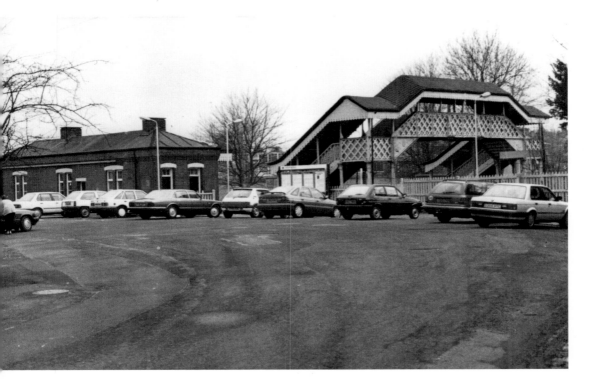

5 February 1994: the station and approach has changed little during the intervening seventy-five years. *Author*

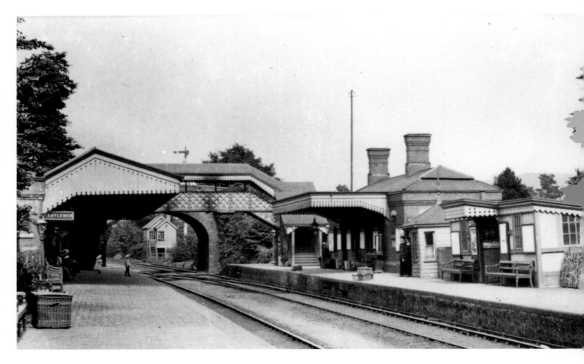

Hagley, view Down, *c.* 1910. Note the extreme height of the home signal and its offside location to ensure visibility above two bridges. *Author's collection*

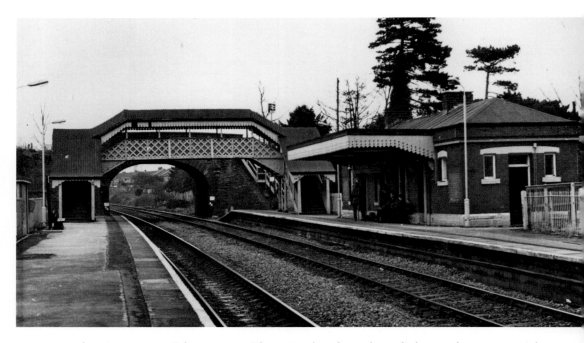

Hagley, view Down 5 February 1994. The station has changed very little over the years – mainly the removal of the supplementary timber buildings, and the signal box which closed on 21 April 1968. *Author*

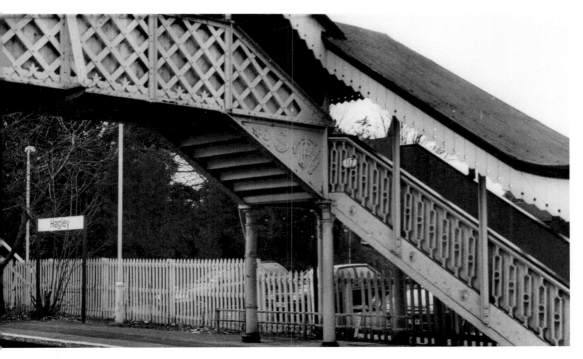

Hagley, 5 February 1994. The centre decoration on the footbridge below the top flight of steps is the date of its construction, 1884. '117' is the bridge number. *Author*

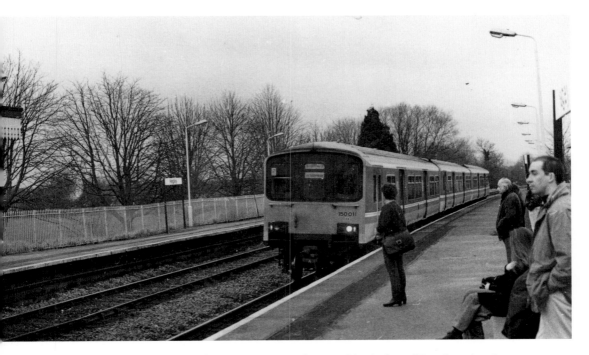

Sprinter No. 150 011 working the 11.58 Great Malvern to Birmingham (New Street) arrives at Hagley, 5 February 1994. *Author*

Left: The Elan Valley to Birmingham aqueduct crosses the line north of Hagley station, 22 August 1961. View from a DMU. *J. E. Cull/Colin Roberts collection*

Below: Staff at the original station, Stourbridge Junction, *c.* 1900. *Lens of Sutton*

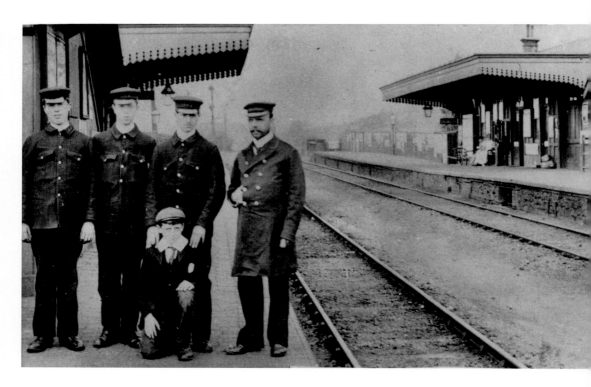

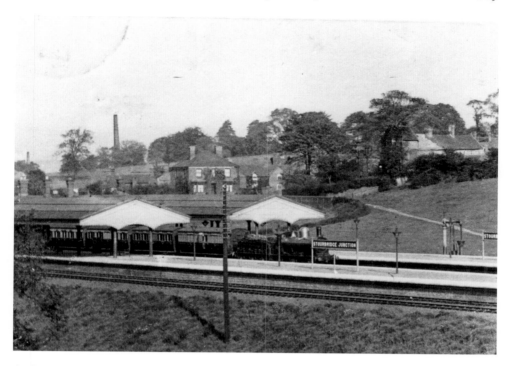

An Armstrong 0-6-0 at Stourbridge Junction heads an Up passenger train. The card was postmarked 11.11.04. *Author's collection*

Stourbridge Junction, 5 February 1994. On the left Sprinter No. 150 102 forms the 12.27 Stourbridge Junction to Birmingham (New Street), while on the right Sprinter No. 150 120 has arrived with the 12.11 Birmingham (New Street) to Stourbridge Junction. The latter is fitted with a small snow plough. *Author*

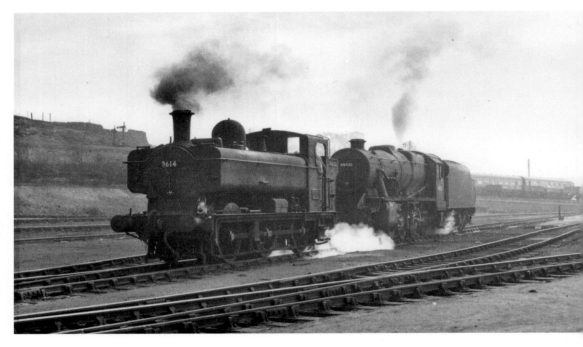

8750 class 0-6-0PT No. 9614 and Class 8F 2-8-0 No. 48430 approach Stourbridge Junction shed, 26 April 1962. No. 48430 was built at Swindon in 1944 and No. 9614 the following year. *Revd Alan Newman*

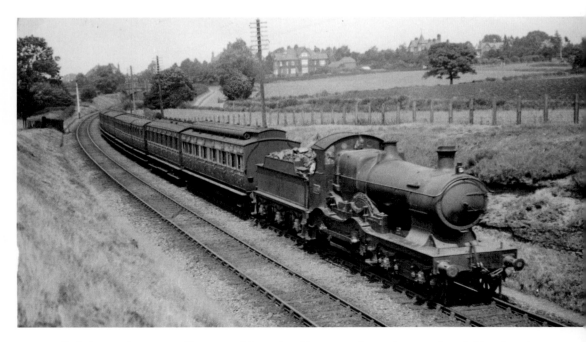

Badminton class 4-4-0 No. 4109 *Monarch* with a stopping train near Stourbridge Junction, 1925. Notice the vacuum reservoir on the roof of the first vehicle, which is a slip coach. *Author's collection*

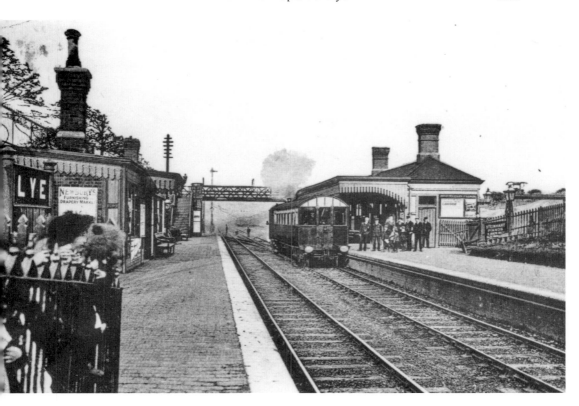

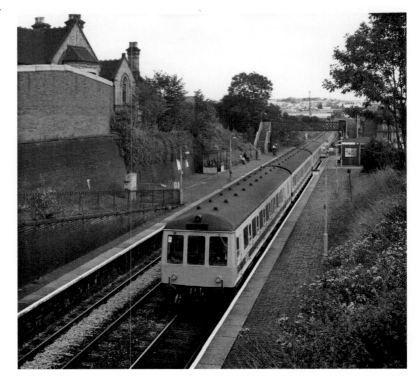

Above: Steam rail motor No. 5 at Lye, *c.* 1906, with an up working. *Author's collection*

Right: A view of Lye station taken from a similar, but slightly higher viewpoint. Two three-car Suburban DMUs working the 11.14 Lichfield (City) to Kidderminster arrive, 3 September 1977. *Michael Mensing*

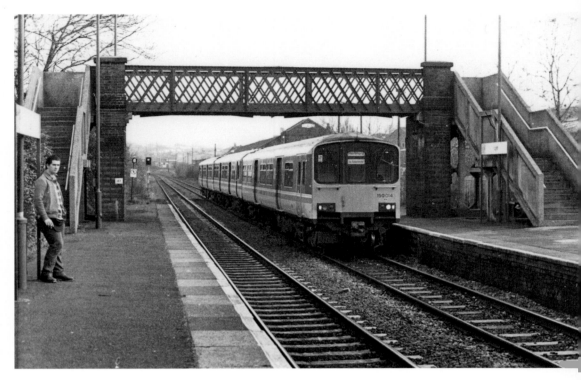

Sprinter No. 150 014 passes Lye on 5 February 1994 with the 11.30 Birmingham (New Street) to Hereford. The roof of the former goods shed can be seen above the DMU. *Author*

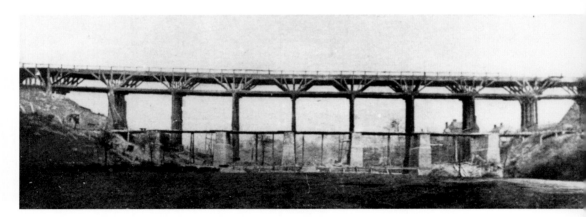

The timber-built Stourbridge Viaduct, 1881. The brick piers of its replacement are being erected in the foreground. *Author's collection*

The line to Dudley crosses the 190-yard-long Stourbridge Viaduct, originally of timber, but replaced by a new brick structure completed on 14 April 1882. Almost immediately beyond was Engine House signal-box controlling the junction with the incline line, closed in 1879, to Stourbridge Goods. Beside this branch, and half a mile from the junction station, was Stourbridge Junction engine shed. The original four-road straight shed with brick walls opened in 1870 and had an allocation of forty-two engines on 1 January 1901. It closed when a GWR standard depot with stabling roads leading from a central turntable was opened in 1926. The new shed was erected by a local builder, A. H. Guest. The old building was retained for use by steam railmotors and trailers, and after their withdrawal was used by diesel railcars. It remained in use, even being partly renewed in 1957 to service DMUs. On 31 December 1947 eighty-four engines were allocated to the depot, but this decreased to sixty-four in March 1959 and thirty-three in May 1965. It closed on 11 July 1966, most of the locomotives being transferred to Tyseley, Oxley, Croes Newydd and Rose Grove. Stourbridge Junction shed, originally GWR code STB, became BR 84F and then 2C in 1963.

Stourbridge Junction is still the terminus for some Up trains and timetables show an increasing frequency of service through the years. In August 1887 nine trains ran between Lye and Stourbridge Junction and ten in the reverse direction, trains on Sundays being five and four respectively. Twelve ran between Droitwich and Stourbridge Junction and thirteen in the Up direction throughout the week. By April 1910 there were no fewer than twenty-four trains scheduled each way between Lye and Stourbridge Junction, and seven each way on Sundays. On weekdays the number of trains between Droitwich and Stourbridge Junction remained the same, while the four each way on Sundays was worse. In July 1922 the service from Lye had increased to thirty-one trains, with twenty-nine Down, other services remaining the same. July 1938 saw even better frequencies, with thirty-eight Up trains from Lye, thirty-five Down and fourteen each way on Sundays. Between Droitwich and Stourbridge Junction there were twenty-two trains, with twenty in the opposite direction and ten each way on Sundays. The timetable for winter 2009/10 shows thirty-seven trains each way daily between Lye and Stourbridge with eight on Sundays. Between Stourbridge Junction and Droitwich there are thirty Up and thirty-one Down trains and fifteen each way on Sundays.

The BR passenger service south of Kidderminster had loadings so light that closure between Stourbridge Junction and Worcester was seriously contemplated. But when HSTs were introduced on Bristol-Gloucester-Birmingham services from 16 May 1983, local trains from Gloucester to Birmingham, which hitherto had travelled via Bromsgrove, were re-routed via Kidderminster in order to leave a clearer path. The new stopping service had semi-fasts from Birmingham to Worcester stopping only at Cradley Heath, Stourbridge Junction, Kidderminster and Droitwich, and hourly stopping trains between Birmingham and Kidderminster.

The line suffered an unusually high number of accidents and mishaps during its early years, the first occurring on the opening day, 1 May 1852. At about 7.00 p.m. half of the directors enjoying the celebratory dinner at the Lion Hotel, Kidderminster, decided to go to Droitwich to catch an MR connection. As the engine driver could not be found – no doubt he was having his own celebration – David Joy, the OWWR's locomotive engineer, drove 2-4-0 engine 'A' to Droitwich and dropped off his passengers. While running round the train before returning to Kidderminster, at the Down end of the station the engine dropped, tender-first, off the bridge over the Droitwich Canal. It was not Joy's fault, but the station-master's who had turned the wrong set of points. The contractor's engine *Jack of Newbury* hauled Joy back onto the road.

Two accidents occurred on the timber Hoobrook Viaduct, Kidderminster. A coupling rod fractured, the two ends punching holes through the viaduct's 3 inch-thick deck planking. A similar fracture happened to a connecting rod while OWWR 0-4-2 *Canary* was crossing tender-first. A broken end crashed through the firebox, causing scalding water and steam to flood back on the train.

OWWR 2-4-0 No. 25 was heading a heavy coal train from Dudley and ran away down the bank into Droitwich. Joe Leedham was its driver, usually referred to as 'Hell Fire Dick' because of his love for speed. As he approached the junction signal it turned from white (clear) to red, giving him no chance to stop, especially as he had only four instead of six coupled wheels. Simultaneously he observed a mail train approaching on the converging line. He had only one chance to avoid a collision. Hell Fire Dick threw open his regulator and the mineral train rushed through the junction ahead of the mail, thus averting a collision.

One advantage of rails being laid on longitudinal, as opposed to cross, sleepers was that in the event of a derailment, trains tended to remain upright. One OWWR passenger engine travelling at about 40 mph near Stourbridge Junction broke its front axle, but due to the track being on longitudinal sleepers, remained upright.

Another incident near Stourbridge Junction occurred in pre-block signalling days while David Joy was riding on the footplate of 2-4-0 No. 26 travelling 'light'. As they sped round a curve they were shocked to see before them a gang of permanent way men on a trolley. Driver George Emby reversed the engine, and the firemen screwed down the tender brakes till, as Joy described it in his diary, 'the water, thrown forward, poured out of the tender like a river. The navvies in no time tipped up the trolley from the "6-foot" and toppled it, going with it down into the ditch, and we rolled over the spot a second later – all right.'

A fatal accident occurred at Stourbridge North Junction at 11.50 p.m. on 17 July 1936. The 9.50 p.m. goods from Victoria Basin, Wolverhampton to Cardiff was standing on the Up main line at the entrance to the Up goods loop, when the 11.30 p.m. Dudley to Stourbridge Junction auto train, wrongly admitted to the section, ran into the brake van of the goods train at not less than 30 mph.

The auto train driver in the control vestibule of the auto was killed and three passengers suffered shock and bruises.

The thirty-six-wagon goods train was hauled by 43XX class 2-6-0 No. 8332 and the single auto coach propelled by 48XX class 0-4-2T No. 4843. Owing to curvature, the tail and side lamps of the brake van would not have been visible to the auto driver until he was close. The goods guard saw a light coming round the curve and jumped from his van just before the impact. Responsibility for the accident was attributed to the signalman at Strourbridge North Junction in that he signalled 'Out of Section' for the goods train when it was actually standing in front of his box.

The OWWR was not unfairly known as the 'Old Worse & Worse', for on 18 October 1855, the 6.45 p.m. express from Oxford to Wolverhampton needed four engines before it could leave Hartlebury. The train engine, 2-4-0 No. 14, was stopped by a tyre jamming against the firebox. The station-master telegraphed to Kidderminster and within half an hour its replacement arrived, 2-4-0 No. 25. Unfortunately the driver could not close his regulator and so proceeded on to Worcester where he reported the problem. The next engine to try and move the train was 0-6-0 No. 10, nicknamed 'Mother Shuter'. This was the Worcester (Shrub Hill) pilot and was driven by no less than David Joy himself. She was coupled up and about to proceed when her water gauge glass blew out, and when Joy attempted to shut off steam from the gauge, one of the studs blew out and yet another engine had to be sent from Worcester. The train eventually arrived at Wolverhampton six hours late.

Another entry in Joy's diary recounts an incident when he had his sleep disturbed.

2-4-0 No. 14, with George Benson taking the 9.35 p.m. down to Dudley, broke a trailing tyre out beyond Hartlebury. I had got to bed when the shedman tickled my window with the usual long stick with the little bunch of wire at the end. Shedman: "Engine off at Hartlebury". I: "Get No. 20 ready". I, to my housekeeper: "Richardson, coffee and toast smart." Then I dressed and found the meal ready. Gulped it quickly and slipped down to the shed, just below me, to find No. 20 crawling out of the shed with 20 lb of steam only. Joe Lester, my man was there, also Adcock, general manager, shivering in the cold, and others. Joe said he could "pick her up", so we started with 20 lb steam. Before we were 10 miles away, past Droitwich, we were springing away like a bird. Arrived at the accident and found it an awfully narrow shave. The trailing tyre had broken through, but held in the one open ring hanging on the engine, till she stuck in the longitudinal timbers, stopping quietly, almost without shaking the passengers. The traffic department took them and handled them, and we tackled the engine and tender to get them out of the way; it was 12 midnight.

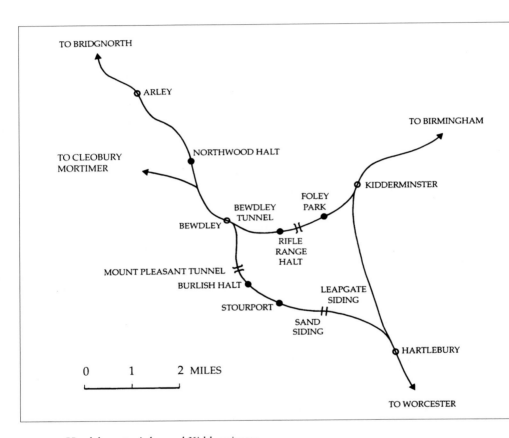

Hartlebury to Arley and Kidderminster.

Hartlebury to Arley – The Severn Valley Railway

The original plan for the Severn Valley Railway was to leave Hartlebury, 11 miles north of Worcester, and run beside the River Severn to Shrewsbury. An Act of 20 August 1853 authorised a capital of £600,000, with borrowing powers of £200,000. Robert Nicholson was appointed engineer, and a contractor, Samuel Morton Peto, the company's chairman in May 1854. Peto held £225,000 worth of shares and at the time was constructing – at cost price – a military railway in the Crimea, and this act gained him a baronetcy in December 1854. On 9 May 1855 Nicholson died aged forty-six and was replaced by John Fowler, later Metropolitan Railway engineer and joint engineer to the Forth Bridge. In 1855, despite the fact that the Mayor of Bridgnorth had rather optimistically stated that 'no more remunerative line would be found in the kingdom', there were relatively few subscribers and economies were planned by making deviations and only laying a single line. A new SVR Act received Royal Assent on 30 July 1855, allowing a capital of £480,000 and borrowing powers of £160,000. Abandonment of the scheme was seriously considered in 1856, but then the OWWR offered to assist and the contractors Brassey, Peto and Betts agreed to construct the line on reasonable terms and accept part payment in shares.

They started work in 1858 and one of the first works was the viaduct over the River Stour between Hartlebury and Stourport. Although only single track was laid initially, overbridges, masonry underbridges and viaducts were built for double track, though tunnels and the rest of the line were on a single-track formation.

Two miles from Hartlebury the line sliced through a sandstone ridge. This required a cutting about a third of a mile in length with a maximum depth of 60 feet. It was made in an unusual manner. A tunnel was bored, then a wagon placed under an intermediate shaft down which spoil was shovelled until the wagon was full, when it was replaced by an empty one. This cunning method avoided men having to lift spoil into the trucks, gravity doing most of the work. A cutting, rather than a tunnel, was necessary to yield sufficient spoil to form an embankment in the Stour valley.

The foundation stone of the Victoria Bridge across the River Severn near Arley, was laid appropriately by Henry Orlando Bridgeman, resident engineer, on 24 November 1859. At that time its span of 200 feet was the largest cast-iron arch in the United Kingdom.

Wet weather during the winter of 1860-1 caused several landslips. Unfortunately serious accidents occurred during construction. On 23 January 1860 a navvy lost an eye and a part of his nose when timber fell on him in Mount Pleasant Tunnel. On 9 January 1861 James Bishop was killed by rocks being blasted in the cutting south of the tunnel, while on 9 March 1861 a navvy working in a cutting south of the Victoria Bridge was lucky to escape death when a 20-lb clod of earth fell on him from a height of about 30 feet. Eventually the works neared completion and it is recorded that on 1 May 1861 a locomotive and twelve ballast wagons passed Bewdley for the first time. Colonel William Yolland made the Board of Trade inspection at the end of December 1861, but failed to pass the line, his main criticism concerning the signalling. The line passed re-inspection on 15 January 1862. The SVR was formally opened on 31 January 1862, a twenty-two-coach special leaving Worcester (Shrub Hill). Public services worked by the West Midland Railway began the following day. The SVR was absorbed by the GWR on 18 July 1872.

To improve the connection from the Birmingham area to the Tenbury branch, it was decided to lay a direct loop from Kidderminster to the southern end of Sandbourne Viaduct, Bewdley. Powers for this were given by the West Midland and Severn Valley Company's Act, 1 August 1861, which authorised the raising of £60,000 by shares and £20,000 by borrowing powers. The London and North Western Railway was to have running powers over the line. Edward Wilson, the OWWR's engineer, was appointed engineer to the new company. As both the Tenbury branch and the SVR were still under construction, work on the loop was held in abeyance.

In 1867 Michael Lane, the Great Western's Chief Civil Engineer, redrew plans for the loop as it had come under the auspices of the GWR in 1863. It was authorised in a GWR Act of 31 July 1868, but the company was not anxious to begin construction work and the tender of Charles Dickinson for £39,800 was not accepted until 7 October 1874. Eventually the line was finished and Colonel Rich, who carried out the Board of Trade inspection on 22 March 1878, was 'surprised and much amused' to find Bewdley Tunnel lit by candles and naphtha lamps. Although he praised highly the bridges and viaducts, the incompletion of other works caused him to decide not to issue a certificate. A second inspection was made on 29 May 1878 and on 1 June 1878 the line between Kidderminster and Bewdley was opened without ceremony.

Competition arrived on 23 May 1898 with the opening of the Kidderminster and Stourport Electric Tramway, one of the first in Great Britain. Much of its track was on sleepers at the roadside. The electric cars hauled trailers and had the first platform vestibules in the country. This tramway caused interference with the GWR's telecommunications and special insulation was required at a cost of £44, this being paid by the British Electric Traction Co. Ltd., the line's owners.

The line between Shrewsbury and Bewdley closed to passengers on 9 September 1963 and through goods trains were withdrawn on 30 November 1963. Although Highley Colliery, north of Arley, closed on 31 January 1969, the line between the colliery and Bewdley remained open for a few days for the

removal of empty wagons, the last regular train running on 6 February. Before the line's closure, as was normal practice, the wage packets of employees on the branch line were delivered by the engine working the goods train, but following closure on 6 February, a class 25 diesel-electric locomotive bearing the headcode 8T91 formerly carried by the branch goods, ran light from Kidderminster to Highley station every Thursday afternoon for the purpose of taking a wage packet to the signalman and another to the shunter who were still stationed at Highley. Another purpose of the train travelling over the line was to ensure that everything was in order and no vandalism had taken place.

A passenger service continued to run between Kidderminster, Bewdley and Hartlebury until 5 January 1970. Coal traffic to Stourport power station ended in March 1979 and the line closed completely from 12 January 1981.

North of Hartlebury station the single track Severn Valley Railway curved north-westwards away from the double-track line to Kidderminster. At Leapgate Siding ground frame, 1½ miles north of the junction, the trailing Leapgate Siding served the Regent Oil Company's depot between 28 August 1939 and 4 January 1970. Up to thirty wagons led by a brake van were permitted to be propelled from Stourport. Beyond Leapgate was Sand Siding, and following the closure of the sand quarry this siding was used for storing coal wagons for Stourport power station. The 73-yard-long Weldon Viaduct and the 37-yard Timber Viaduct were crossed, and before passing over the Staffordshire and Worcestershire Canal on a 33-foot-span bridge, a double-track section began, a siding opened in 1940 from the Central Electricity Generating Board's works trailing into the Down line. The CEGB had two 0-4-0STs, one built by Barclay and the other by Peckett.

In the nineteenth century a siding, to which access was gained by a wagon turntable, ran parallel with the Staffordshire and Worcestershire Canal on the west side of the line and was used for exchange traffic, but traffic developed to such an extent that in 1885 the GWR paid for a basin and warehouse. Two sidings served this basin situated on the east side of the branch. Iron and steel from South Wales and coal from Highley Colliery further up the SVR, were brought to this basin for transit to Wilden Iron Works.

Latterly Stourport, renamed Stourport-on-Severn in October 1934, had a sizeable goods yard south of the passenger station, its coal yard being to the north. An economy was made on 1 April 1951 when Stourport South signal-box closed and the North signal-box had its frame extended. At the north end of the complex where the double track became single, one private siding led to Steatite and Porcelain Products Limited's works, and beyond a siding trailed in from the National Cold Stores.

The line rose at 1 in 150 to Burlish Halt situated on the Down side of the line. The halt, with a concrete platform, corrugated iron pagoda and electric lighting, opened on 31 March 1930 at a cost of £300 for engineering, £80 for the Chief Mechanical Engineer's expenses and £50 for the land. The siding to the porcelain works passed behind the halt.

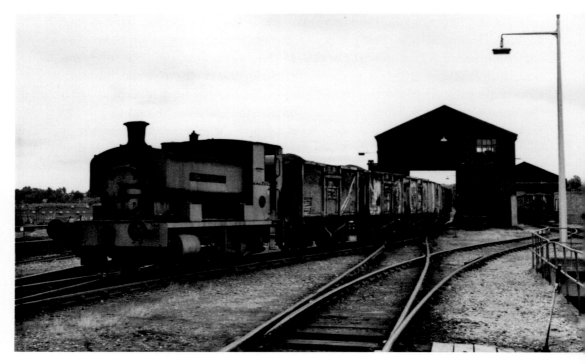

Andrew Barclay 0-4-0ST No. 2088 *Sir Thomas Royden*, built in 1940, shunts at Stourport power station, 21 June 1970. *Hugh Ballantyne*

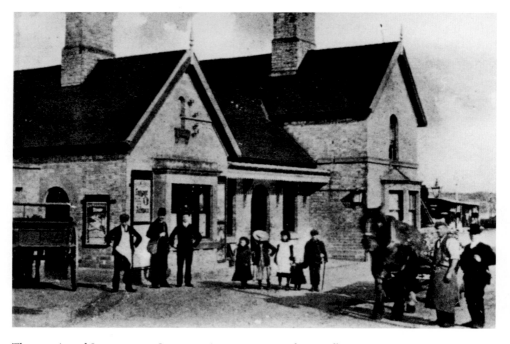

The exterior of Stourport-on-Severn station, *c.* 1900. *Author's collection*

Right: Stourport-on-Severn, view Down, 3 February 1968, with the coal yard siding on the left. The grating in the foreground catches any water spilled from the bag of the water crane. Notice the centre-pivoted signals used in this confined location. The signal box is Stourport North. The DMU has just arrived from Hartlebury. *D. Payne*

Below: The first steam railmotor arrives at Stourport-on-Severn, 29 December 1904. Numbered 35, it was brand-new. Notice the clean buffers and polished cylinder cover. Bystanders find the photographer more interesting than the railmotor. No. 35 was withdrawn in October 1918 to become trailer No. 132. *Author's collection*

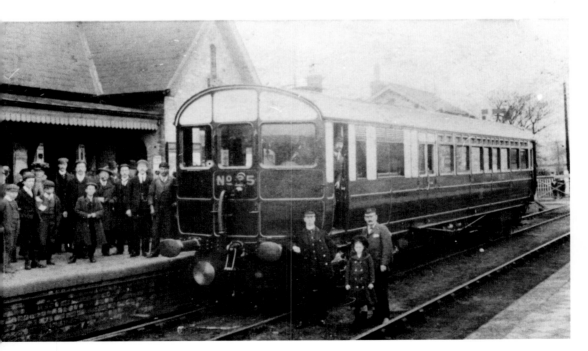

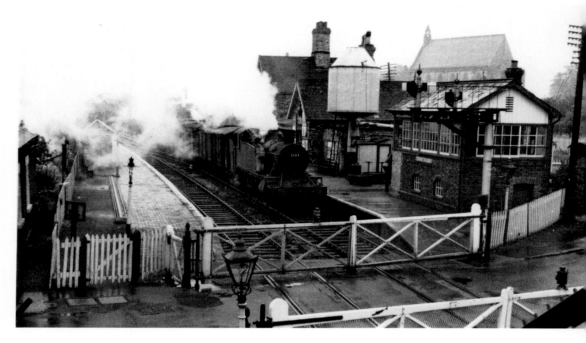

5101 class 2-6-2T No. 5153 at Stourport-on-Severn, *c.* 1960, with a Down goods train. This photograph was taken from the footbridge which was used when the level crossing gates were closed across the road. Notice that the signal box has been extended at its far end. The water tank is mushroom-shaped. *Lens of Sutton*

A wagon label for perishable goods travelling from Stourport to Bristol, 2 November 1911. *Colin Roberts collection*

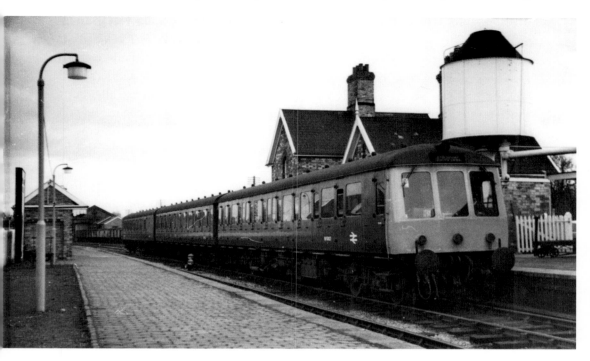

A Derby Works three-car Suburban DMU from Hartlebury at Stourport-on-Severn, 3 February 1968. Its leading car is No. M50107. *D. Payne*

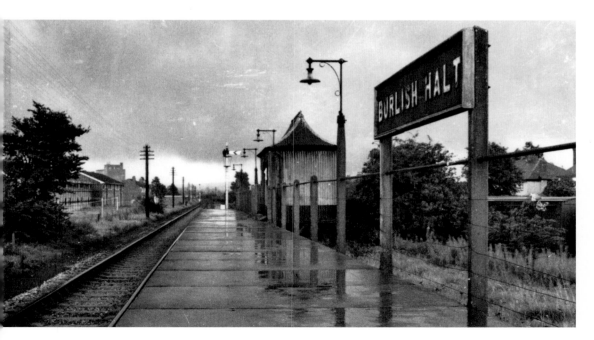

Burlish Halt, *c.* 1960, with its corrugated iron pagoda hut, view towards Stourport. The distant signal is for Bewdley South. *Lens of Sutton*

The branch passed through a sandstone cutting and descended at 1 in 100 through the 123-yard-long Mount Pleasant Tunnel at 85½ feet beneath the surface. The cutting at its north end was made wide in order to provide sufficient spoil for making the embankment beyond. The loop from Kidderminster, now part of the preserved SVR came in and the two lines ran parallel across Sandbourne Viaduct, 101 yards long, before the double track began. Bewdley bypass was crossed on a skew bridge of 60 foot span. The 2,500-ton concrete bridge was pushed about 150 feet into position on 6 November 1986 and first used by trains on 29 November.

The Up platform at Bewdley is an island, thus giving the station three platform faces. The opening of the Kidderminster loop in 1878 required the enlargement of the island platform and provision of a footbridge to cope with the additional traffic. Bewdley became very busy with over sixty trains using it daily. A whistle code was used:

For SVR Up and Down	1 whistle
To and from the Tenbury line	2 whistles
To and from Kidderminster	3 whistles

Bewdley closed to goods on 1 February 1965.

Northwood Halt, its platform a sleeper wall backfilled with spoil and surmounted by a timber waiting shelter, opened on 17 June 1935. It was situated on the Up side of the line. The SVR crosses the River Severn by means of the Victoria Bridge. It is a splendid structure in a scenic setting. The 200 foot span has four ribs, each rib consisting of nine segments. The total weight of iron in the bridge comes to about 500 tons. It is inscribed 'Messrs Brassey & Co, Contractors, Victoria Bridge 1861. John Fowler, Engineer. Cast and erected by the Coalbrookdale Company'. When it was painted in 1980 264 gallons were required. As the ends of the cast-iron girders and the cross-bracing had become corroded and the stone blocks bearing the girders cracked, early in 1994 £200,000 was spent on restoration. Not far beyond the bridge is Arley, a simple crossing loop with two sidings. The passenger station has a yellow-brick building with a slated roof. Arley originally had one platform on the east side, the second platform opening in June 1883, and both were lengthened in 1907. In 1938 a camping coach was parked at the station for use by holiday-makers. Despite the accident at Abermule on 26 January 1921, when two trains collided head-on on the Cambrian Railways single line due to confusion caused by the tablet instruments being kept in the station booking office instead of the signal-box, they remained in the booking office at Arley until the SVR preservationists wisely transferred them to the signal-box. Arley closed to goods on 9 September 1963. Today Arley is a most attractive station and has a large picnic area garden. Half a mile north the SVR enters Shropshire.

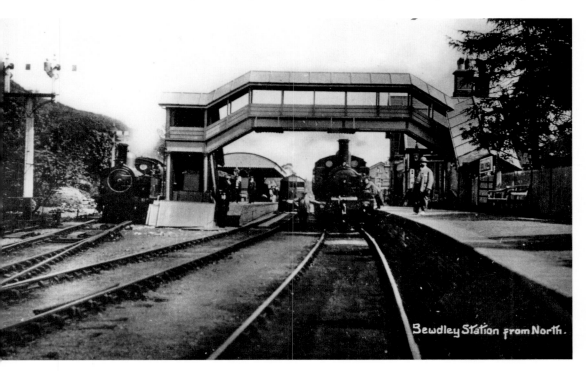

Bewdley, view towards Hartlebury, *c.* 1910. The train on the left is probably for Woofferton Junction. In the centre is a steam rail motor bound for Kidderminster or Hartlebury, while on the right is a tank engine probably heading a train for Shrewsbury. The footbridge has shallow girders. *Author's collection*

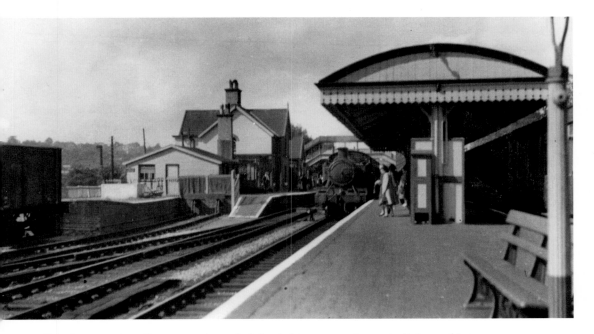

Bewdley, *c.* 1960: a Down stopping train is hauled by a 4575 class 2-6-2T. *Lens of Sutton.*

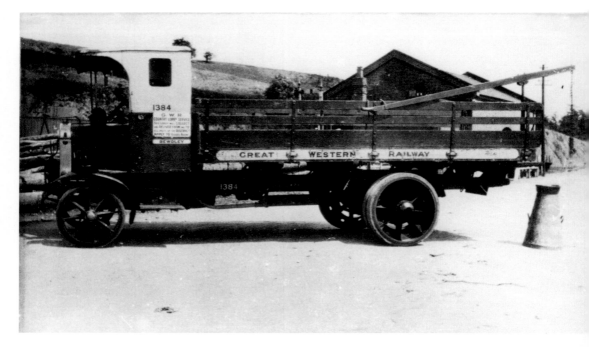

GWR Thornycroft lorry No. 1384 at Bewdley, 13 June 1929, fitted with a jib for loading milk churns. The notice on the cabside reads: 'GWR Country Lorry Service. This lorry will collect and deliver from and to all parts of the district. Apply to Goods Agent'. *Author's collection*

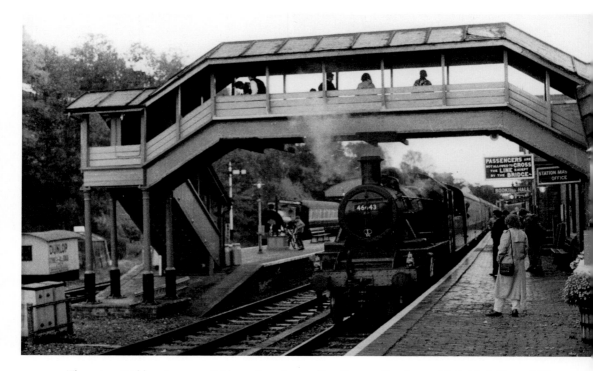

The 16.45 Kidderminster to Bridgnorth arrives at Bewdley, 13 October 1988, behind Class 2MT 2-6-0 No. 46443. *Author*

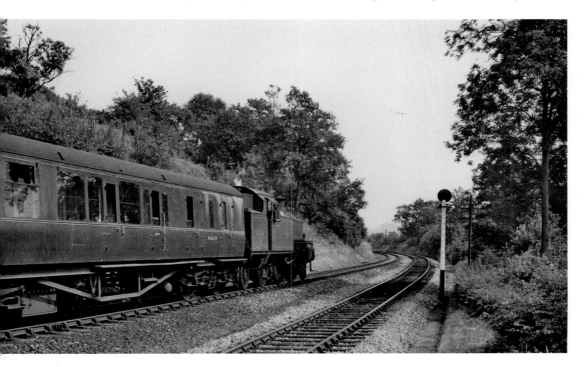

Class 3P 2-6-2T No. 40126 approaches Bewdley with the 1.45 p.m. Shrewsbury to Kidderminster, 25 June 1960. The Tenbury line is on the right. *Michael Mensing*

Northwood Halt, view Down, *c.* 1960. *Lens of Sutton*

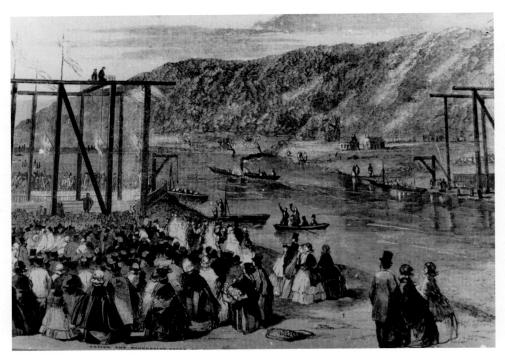

The foundation stone of the Victoria Bridge being laid on 24 November 1859. This sketch was drawn by Alexander G. Linn, assistant engineer to the Severn Valley Railway. *Author's collection*

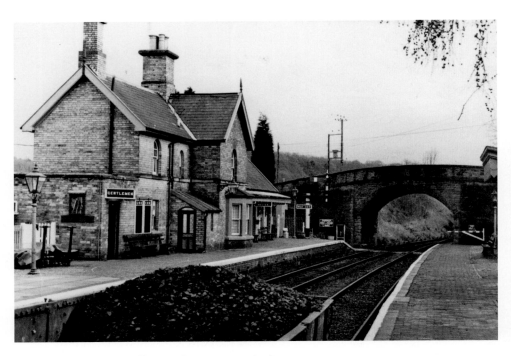

Arley, view towards Bewdley, 5 February 1994. *Author*

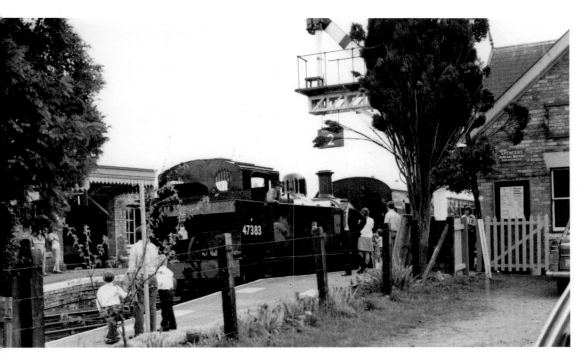

Class 3F 0-6-0T No. 47383 at Arley, 20 April 1975. *W. H. Harbor*

0-6-0ST *Coventry* No. 4 and *Joan* at the National Coal Board's pit, Arley, 1 May 1967. *Revd Alan Newman*

A line-up of 0-4-0STs at the National Coal Board's mine, Arley, 25 September 1963: *Edith, Queen* and *Empress*. 'X' painted on a wagon indicates 'For Internal Use Only'. *Revd Alan Newman*

The whistle code at Kidderminster Junction was:

To main line Up and Down	1 whistle
To and from branch line	2 whistles

From Kidderminster Junction the single-track loop to Bewdley, falling at 1 in 112, curved past the locomotive depot, now a housing estate, crossed the Worcester Road by a 30-foot-span brick arch and went over the 132-yard Kidderminster Viaduct, consisting of seven red-brick arches of 46 foot span over the River Stour and the Staffordshire and Worcestershire Canal.

At the far end of the viaduct the line rose at 1 in 114 to Foley Park Halt, the sleeper platform having a corrugated iron pagoda. Opened on 2 January 1905, it was originally situated on the south side of the line, but construction of sidings caused it to be moved to the other side of the track. The sidings led to the British Sugar Corporation's factory and were in use between 1929 and 1980. Loaded trains of sugar beet were propelled to Foley Park from Kidderminster with the brake van leading. The return up the gradient with about seventy empties and a van set the 0-6-0PT a considerable task.

Beyond was Rifle Range Halt, opened in June 1905 at a cost of £145 and closed on 4 October 1920, although retained in unadvertised use 'for firing

parties' until some date after 1930. The line descended at 1 in 100 through the 486-yard-long Bewdley Tunnel. In 1910 it required a new arch of blue brick at a cost of £3,247. The line was kept open and forty men were at work each night from 3 August until 20 October 1910, the scaffolding having to be removed before the first train in the morning. North of the tunnel the line ran parallel with the branch from Hartlebury and Stourport and crossed the 101-yard-long Sandbourne Viaduct, its ten brick arches resting on sandstone piers.

In the 1880s the SVR passenger service was important enough to be worked by tender engines and bogie clerestory stock at a period when many branches had to be content with tank engines hauling four-wheelers. Locomotives known to have worked SVR passenger trains in the nineteenth century were four double-framed WMR 2-4-0s Nos 93-96 (GWR Nos 190-193); GWR 171 class double-framed 2-4-0s; Standard Goods 0-6-0s; 927 class 0-6-0s; 439 class 2-4-0s; 2021 class 0-6-0STs; and Metro class 2-4-0Ts. One interesting engine was ex-Midland and South Western Junction Railway 4-4-4T GWR No. 27 which, following rebuilding with a GWR boiler in 1925, often worked Bewdley to Snow Hill trains. During the 1930s 2301 class 0-6-0s appeared and in the Second World War Collett 0-6-0s worked passenger services, as did GWR diesel railcars Nos 19, 25 and 33. LNER J25 class 0-6-0s Nos 2059, 2061 and 2142, on loan to the GWR, worked some goods trains. In the postwar era 51XX and 45XX 2-6-2Ts were to be seen, together with 2251 class 0-6-0s and 'Duke' class 4-4-0s No. 3273 *Mounts Bay* and No. 3276. Latterly 57XX class 0-6-0PTs and ex-LMS Class 2 3-6-2Ts provided motive power.

With the opening of the line in February 1862, three trains ran each way daily on the SVR, taking about thirty-one minutes between Hartlebury and Arley, a frequency increased after the experience of the first few months to four. A Sunday service of a solitary train each way was introduced in March 1862. In 1876 two weekday and one Sunday train ran through to Worcester. In 1904 six through trains were offered plus one between Bridgnorth and Hartlebury. This frequency lasted for many years. In 1947 only one through train ran from Shrewsbury to Hartlebury, with three in the reverse direction, other trains requiring passengers to change. In 1960 a service of three trains was provided between Arley and Hartlebury, with four in the other direction.

On 29 December 1904 a steam railmotor ran a trial service from Kidderminster to Bewdley and Stourport, with a regular service starting on 2 January 1905 using two motors. By 1910 there were nine Down and ten Up trains daily and one Up on Sundays, all taking about twenty minutes for the journey of 6¼ miles. As a reversal was necessary at Bewdley, railmotors were ideal for operating this service. By 1938 the auto service declined to four to Stourport and seven return.

The new Severn Valley Railway was incorporated on 24 May 1967 and has become one of the largest preserved railways in Britain, with six stations, over thirty steam engines and more than half a dozen diesels. Passengers can enjoy beautiful scenery not visible from roads. Passenger services began on 23 May 1970

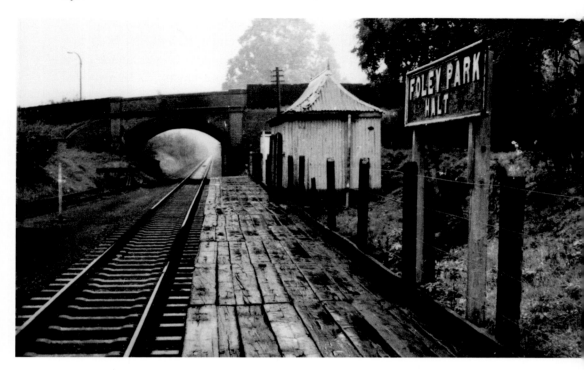

The corrugated iron pagoda at Foley Park. View towards Bewdley, *c.* 1965, standing on a platform made from old sleepers. The overbridge is wide enough for double track. One of the sugar factory sidings can be seen on the left. *Lens of Sutton*

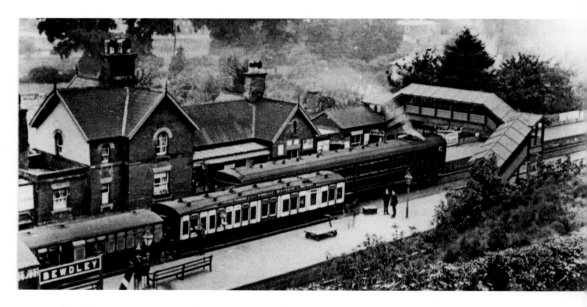

Bewdley, *c.* 1909: steam railmotor No. 91 in brown livery. An LNWR through coach is at the rear of a Woofferton Junction to Birmingham train. Its roof board reads: 'Through Carriage between Birmingham and Woofferton via Smethwick.' *Author's collection*

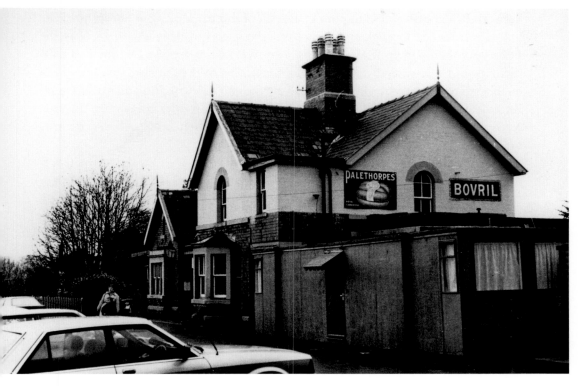

The exterior of Bewdley station, 5 February 1994. *Author*

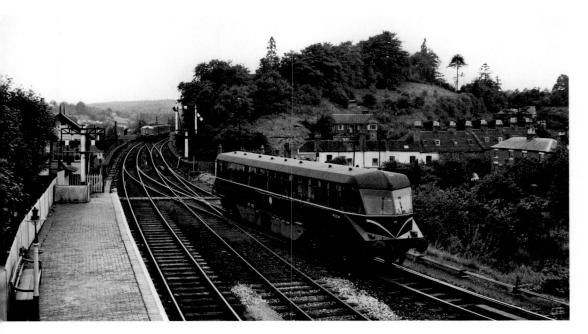

Ex-GWR diesel railcar No. W22W, now preserved, arrives at Bewdley, 15 August 1959. *Michael Mensing*

between Bridgnorth and Hampton Loade, all of this track being in Shropshire. The line was extended to Highley on 12 April 1974, and to Bewdley on 18 May the same year, the first trip being made by ex-GWR railcar No. 22 and the first SVR steam train to Bewdley by 0-6-0PT No. 5764. The SVR flourished and grew to a membership of 5,000 by 1974 and 9029 by the end of 1979. In 1984 the link with BR at Kidderminster opened. On the site of part of the former goods yard the SVR erected a new terminal passenger station building of red brick, relieved by grey brick around window and door openings.

It was based on an 1890 design for Ross-on-Wye by J. E. Danks of the GWR Civil Engineer's Department. It has a double-faced platform. The first passenger train to visit for clearance tests arrived behind No. 6960 *Raveningham Hall* on 27 July 1984 and the station opened three days later. On 12 December 1984 the junction with BR was passed for passenger traffic and the first through working took place on 29 December. The new station building, as opposed to just the platform, opened to the public on 28 September 1985, though its official opening was not until 4 July 1986. In 1985 the former goods shed at Kidderminster was purchased for use by the SVR's Carriage and Wagon Department, and at the end of 1986 a new Kidderminster Station signal-box with a 62-lever frame was opened.

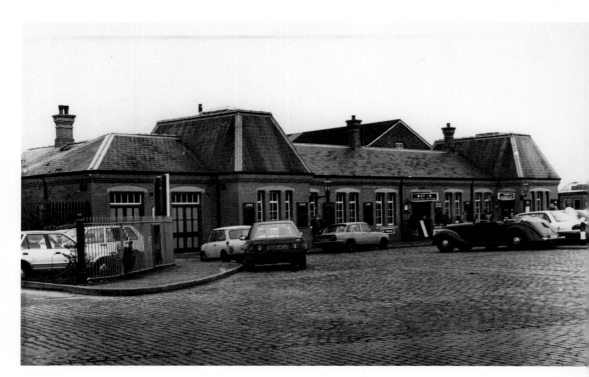

The exterior of the Severn Valley Railway's Kidderminster station, 5 February 1994. It was built in the GWR style of the 1890s. *Author*

The circulating area of the SVR's Kidderminster station, 13 May 2008. *Marguerite Hampton*

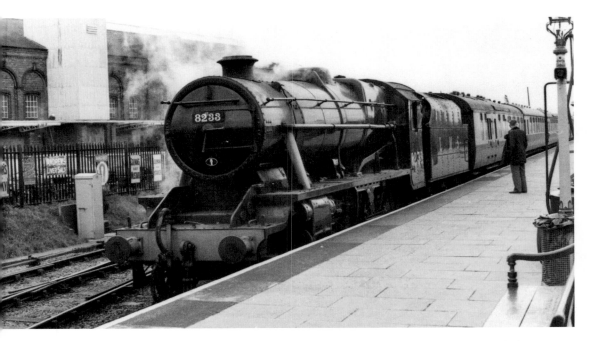

The SVR Kidderminster station, 13 October 1988: Class 8F 2-8-0 No. 8233 with empty stock for the 11.55 working to Bridgnorth. In the Second World War No. 8233 served in France, Iran and Egypt and bears a plate to the effect. *Author*

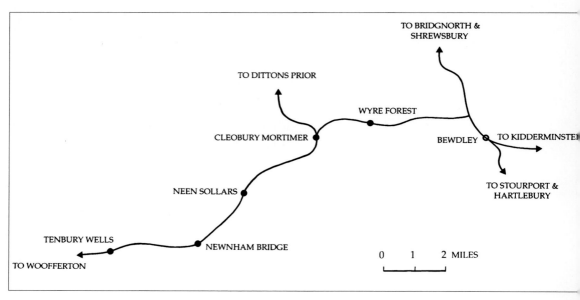

Bewdley to Newnham Bridge.

Bewdley to Newnham Bridge

The Tenbury Railway opened on 1 August 1861 from Woofferton, on the Shrewsbury and Hereford line, and was extended by the Tenbury, Bewdley, Kidderminster and Worcester Junction Railway to join the Severn Valley Railway at Bewdley, the necessary Act on 3 July 1860 allowing it to raise £120,000 by shares and £40,000 in loans. The line was engineered by John Fowler, assisted by D. Wylie. Later, Fowler was to be the co-designer of the Forth Bridge and consulting engineer for London's first tube railway. The contract for building the line was let to Brassey and Field.

On 5 August 1864 work was sufficiently advanced for the directors and their friends to make a trial trip along the completed line. The Board of Trade inspection took place on 9 August 1864 and public traffic commenced on 13 August. The TBKWJR was worked by the GWR and vested in that company by an Act of 12 July 1869.

Although passenger traffic was withdrawn from the branch on 1 August 1962, an experimental service was introduced from Tenbury to Bewdley. This weekday morning train and a return in the evening survived until 1 August 1963. General goods traffic ended on 6 January 1964 and the branch closed entirely on 15 April 1965 when there was no more traffic from the Cleobury Mortimer and Dittons Prior Light Railway, which had been owned by the Royal Naval Armaments Depot since 30 September 1957, when it purchased the line from BR to give access to its store.

At the north end of Bewdley Viaduct the Tenbury branch ran parallel with the SVR and a mile north of Bewdley station curved and descended westwards to Dowles Bridge over the River Severn. This structure consisted of three lattice girder deck spans each 70 feet long. Beyond was an ascent to Cleobury Mortimer, with a ruling gradient of 1 in 70. Wyre Forest station consisted of a platform and siding on the Up side of the single track. By 1925 its signal-box was closed and replaced with a ground frame. Just west of the station, the branch, which had closely followed the county boundary, entered Shropshire.

Cleobury Mortimer, just in Shropshire, had a passing loop, while additional sidings were laid to cope with increased traffic brought by the opening of the Dittons Prior branch to goods on 1 July 1908 and to passengers on 19 November. South of Cleobury Mortimer the branch re-entered Worcestershire and just before Neen Stollars crossed the River Rea on a brick bridge.

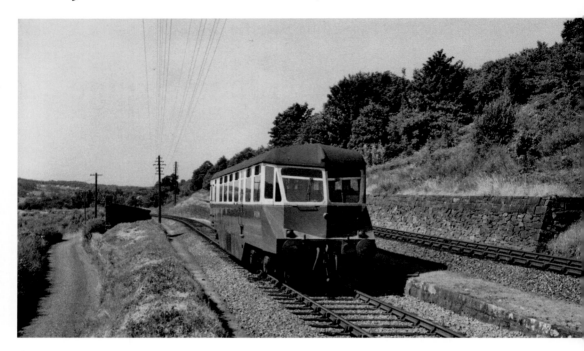

Ex-GWR diesel railcar No. W20W rises to approach the Bridgnorth to Stourport line which it will run parallel with to Bewdley. The train is the 3.05 p.m. Tenbury to Kidderminster, 20 June 1959. *Michael Mensing*

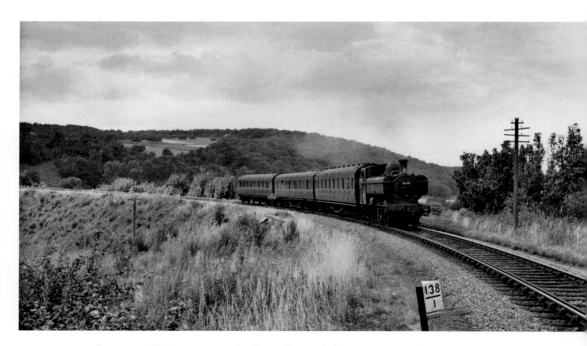

8750 class 0-6-0PT No. 4641 north of Bewdley with the 3.05 p.m. Tenbury to Kidderminster, 15 August 1959. Note the quarter mile post in the foreground, this distance being measured from Paddington via Oxford and Worcester. *Michael Mensing*

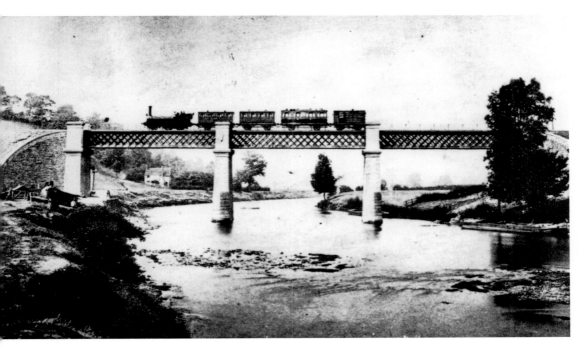

2-4-0WT No. 1A crosses Dowles Bridge with the Board of Trade inspector's train, 9 August 1864. The barge on the far right was used by the line's contractor, Thomas Brassey. *Author's collection*

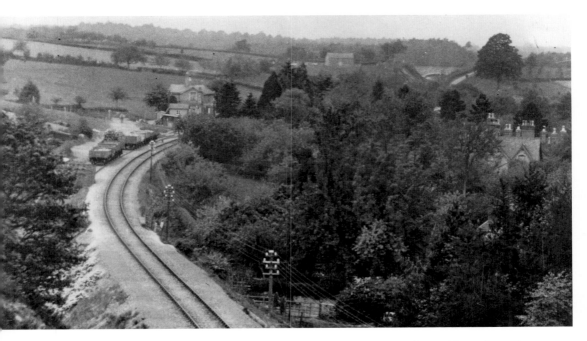

Wyre Forest station, view towards Newnham Bridge, *c.* 1910. The station is busy with goods traffic, nine wagons being in the siding. *Author's collection*

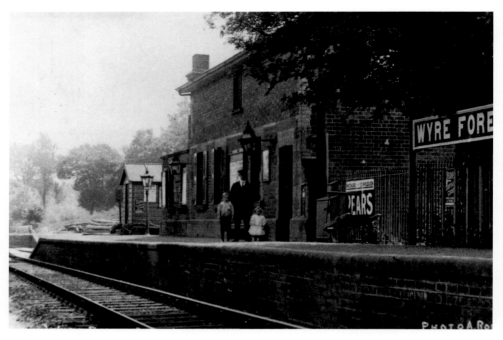

Wyre Forest station, view towards Bewdley, *c.* 1910. Unusually, the ground floor windows have shutters, while the built-in post box was a more usual feature. *Author's collection*

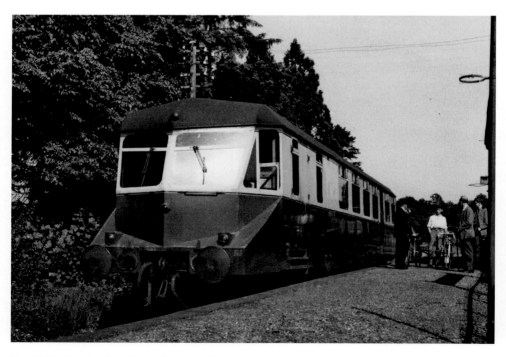

Ex-GWR diesel railcar No. W20W calls at Wyre Forest with the 4.10 p.m. Kidderminster to Tenbury, 20 June 1959. Evidently no problem existed with bicycle conveyance by railcar in 1959! *Michael Mensing*

Neen Stollars, originally with a single platform on the Down side and a goods loop beyond, had its loop extended on 13 July 1924 when a Down platform was added. This feature was taken out of use and the layout simplified with the closure of the signal-box on 22 August 1954.

The line closely followed the bank of the River Rea to Newnham Bridge station, which had a single platform on the Down side of the line. The goods yard was sited east of the passenger station. Fairly early in this century its signal-box was closed and replaced by three ground frames, and a loop added opposite the passenger platform. As access to the latter could only be across the running line, the Working Time Table Appendix stipulated: 'Loading and Unloading of Heavy Goods to and from Road Vehicles at the platform obstructing the running line ... the practice of backing vehicles to the platform must not be resorted to when it is possible to avoid it.' Traffic sent from the station included fruit and rabbits. About midway to Tenbury the line recrossed into Shropshire.

Early in the twentieth century passenger trains tended to be worked by Metro class 2-4-0Ts, 517 class 0-4-2Ts and Dean Goods 0-6-0s. In 1931 it was recorded that a Metro tank and a 1661 class 0-6-0PT were at work. From 1941 GWR diesel railcars Nos 19, 25 and 33 were to be seen, together with 45XX 2-6-2Ts.

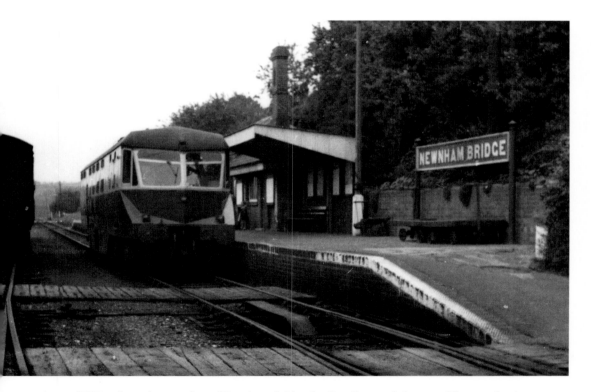

An ex-GWR railcar about to leave Newnham Bridge for Bewdley, 21 July 1956. The crossing in the foreground is constructed from old sleepers. Notice the fruit vans in the siding on the left. *G. Bannister*

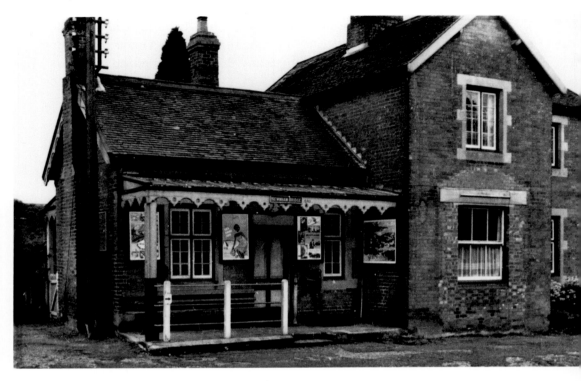

Newnham Bridge station, *c.* 1960. *Lens of Sutton*

The flight of steps from the pavement to Newnham Bridge station, *c.* 1960, give it a domestic appearance. *Lens of Sutton*

During the Second World War, LNER J25 class 0-6-0s Nos 2059, 2061 and 2142, on loan to the GWR, were sometimes used on the Stourbridge to Hereford goods train. They performed well on the gradient to Cleobury Mortimer, but were very heavy on coal. Collett 0-6-0s and Aberdare class 2-6-0s could be seen on Hereford to Stourbridge freights. Kidderminster Co-operative Society chartered trains during the summer for day excursions to various resorts, those to South Wales usually involving a route over the Tenbury branch. The train of ten coaches and a buffet car was handled by a 2-6-0 and 2-6-2T.

The passenger service varied very little over the years in either frequency, or the time taken for a journey from Bewdley to Newnham Bridge, which remained at thirty-five minutes. In 1887 four trains were scheduled to run each way; in the 1920s it was five and in the summer of 1930, six. During the Second World War the service was reduced to four but increased to five in postwar years. With the opening of the Kidderminster Loop on 1 June 1878 a through service was introduced between Birmingham and Woofferton, as this could now be operated without the need for reversal. This included an LNWR through coach coupled at Smethwick Junction to the GWR train which originated at Birmingham (Snow Hill). This working ceased on 1 January 1917. With the opening of the Kidderminster Loop, the Down direction on the Tenbury branch was reversed, Bewdley to Newnham Bridge becoming Up.

Fares.]			**WORCESTER and BROMYARD.—G. W.**						
1 cl.	2 cl.	3 cl.	Shrub Hill,	gov	mrn	mrn	aft	gov	
s. d.	s. d.	s. d.	Worcester........dep	7 50	9 30	1130	2 20	6 20
0 3	0 2	0 1½	„ Foregate Street.	7 52	9 32	1132	2 22	6 22
0 6	0 4	0 3	Henwick	7 57	9 39	1137	2 27	6 27
1 6	1 0	0 9	Leigh Court	8 7	9 49	1149	2 37	6 39
2 0	1 4	1 0	Knightwick	8 14	9 56	1157	2 44	6 47
2 8	1 6	1 1½	Suckley	8 16	10 0	12 1	2 48	6 51
3 0	2 4	1 6½	Bromyardarr	8 30	1012	1215	3 0	7 5
Fares.				gov	mrn	aft	aft	gov	
1 cl.	2 cl.	3 cl.	Bromyard........dep	8 40	1020	1 2	5 0	7 15
.....	Suckley	8 52	1032	1 14	5 14	7 27
.....	Knightwick	8 56	1036	1 18	5 18	7 31
.....	Leigh Court...........	9 3	1043	1 25	5 26	7 38
.....	Henwick 32....[Street	9 12	1053	1 35	5 37	7 48
.....	Worcester, Foregate	9 15	1055	1 37	5 40	7 50
.....	„ Shrub Hill 29	9 20	11 0	1 42	5 45	7 55

Bradshaws' *Railway Guide*, August 1887.

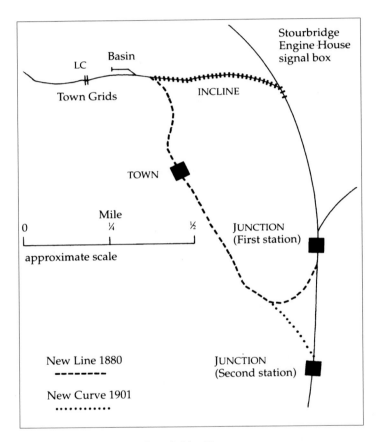

Strourbridge Junction to Stourbridge Town.

Stourbridge Junction to Stourbridge Town

The OWWR Act of 23 July 1858 authorised an inclined railway which left the Stourbridge Junction to Wolverhampton line at Stourbridge Engine House signal-box and descended past the incline's engine house to the canal basin. Construction began in April 1859, the opening ceremony taking place on 30 July the same year – though a locomotive and four horses were used as the winding engine had yet to be installed. This haste was necessary because the Act stipulated that the line must be opened by 31 July 1859. The branch did not open properly for nearly another two years. The incline closed on 1 January 1880, being rendered redundant by a new branch with somewhat easier gradients.

On 5 July 1865 the Stourbridge Railway obtained powers for building the Stourbridge Town branch and the following year an Act of 16 July allowed a deviation of route. No concrete action was taken before 1 February 1870, when the Stourbridge Railway was vested in the GWR. The original powers having lapsed, on 30 June 1874 the GWR obtained an Act for the construction of the line, though work did not begin until the late spring of 1878. It opened for passengers on 1 October 1879 and to goods on 1 January 1880. As mentioned on page 103, the re-siting of Stourbridge Junction station necessitated modifying the main line end of the branch and this was brought into use on 1 October 1901. As a wartime economy measure the branch closed to passengers on 29 March 1915, trains being replaced by GWR buses. The rail passenger service was restored on 3 March 1919, but closed again during the 1926 General Strike, when GWR AEC buses operated a service between 7 May and 10 July. Stourbridge Basin closed to goods on 5 July 1965, the Town closing to goods traffic a few months later on 20 September, but the branch was not singled and the goods line taken out of use until 22 October 1967.

Less than three-quarters of a mile in length, the branch is the shortest on the national system; the change at Stourbridge Junction is irritating and to some extent time-wasting. From 27 August 1935 the double track was converted to one passenger and one goods line, the Up line becoming Up and Down goods. Each line was worked with a wooden train staff under the 'one engine in steam' system, this economy of having two parallel single lines enabling Stourbridge Town signal-box to be closed on 27 August 1935.

Stourbridge Junction station opened simply as 'Stourbridge' on 1 May 1852, 'Junction' being added on 1 October 1879 when the town branch opened. In

March 1897 the GWR decided to rebuild the station twenty-two chains to the south and the new station, with two 700-foot-long island platforms opened on 1 October 1901. The branch line near the junction was re-aligned, a rather more direct run replacing a 135 degree curve. The repositioning of the station at its new site, released land for a new marshalling yard. In 1996 the Junction station was refurbished at a cost of £400,000.

From the junction the branch falls at 1 in 67 and during the 1980s at least two DMUs ran through the buffers into the bus station. Stourbridge Town had a largish, light-coloured brick-built passenger station decorated with red brick and stone sills and lintels. It was situated on the Down side of the line. In 1931 Passimeter equipment was installed at a cost of £204, the turnstile allowing the booking clerk to control access to and from the platform and obviating the need for a ticket collector. The station lost its platform canopy in the 1970s. On 18 February 1979 a new 57-yard-long platform was opened 52 yards nearer Stourbridge Junction, the old station site becoming part of the enlarged bus station. The new platform, with a bus shelter as a waiting room, was Stand L of the bus station. Yet another new station was built in 1994; the branch temporarily closed from 10 January while works were taking place. The branch was shortened by 30 yards to accommodate an even larger bus station. The new 170-foot-long platform opened 25 April 1994.

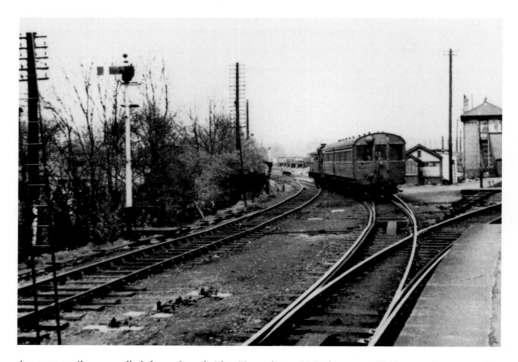

An auto trailer propelled from Stourbridge Town by 14XX class 0-4-2T No. 1438, approaches Stourbridge Junction, *c.* 1954. It is crossing the former Down line, as from 1935, passenger trains in both directions used the Down line and all goods trains the Up line. *M. E. J. Deane*

The attractively painted overbridges near Stourbridge Junction station, 5 February 1994. The Town branch is in the foreground, with the main line beyond. The BR/Centro sign towards the top right marks the entrance to the drive to Stourbridge Junction station. *Author*

The Stourbridge Town branch replacement bus service, 5 February 1994. *Author*

Left: The Stourbridge Town branch closure notice, 5 February 1994: 'The Town Service has been suspended for 15 weeks. Buses will be operating from the main car park near to Platform 3.' *Author*

Below: Contractor's plant for building the new Stourbridge Town station, 5 February 1994. *Author*

The original station was the railhead for the GWR bus service to Hagley and Belbroughton, and commenced on 13 February 1905 using Milnes-Daimler double-deckers. Later the route was extended to Catshill and Bromsgrove, the service being withdrawn on 5 August 1916.

Beyond the passenger station the single-track goods line descended at 1 in 27 and the Operating Appendix ruled: 'In all cases guards working Up or Down branch trains must ride outside their van compartment at the hand brake in readiness to give instant attention.' The line crossed the River Stour and curved round past the gasworks to the basin of the Stourbridge Canal. Here were two goods sheds, a transit shed, and goods and private sidings. The line re-crossed the River Stour to the ironworks of Messrs Bradley and Company. Until the track was lifted, the rails at Lower High Street bore grooves where the 3-foot-6-inch-gauge Dudley, Stourbridge and District Electric Traction Company Limited's tramway crossed.

Steam railmotors were introduced to the branch in January 1905 and worked it for over thirty years. In fact it was one of their last haunts and they made almost sixty trips daily until October 1935. The interior of a railmotor was gas-lit, the exterior oil head lamp supplied by the Locomotive Department and the tail lamp by the Carriage Department. As well as the saloons being well-cleaned daily at Stourbridge locomotive depot, the station-master arranged for them to be swept out and kept 'thoroughly clean' during the day. Less than six months after the cessation of the steam railmotors, diesel railcars made their appearance.

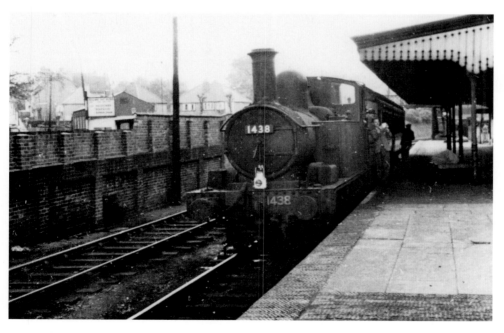

14XX class 0-4-2T No. 1438 at Stourbridge Town, view towards Stourbridge Junction, *c.* 1954. *M .E. J. Deane*

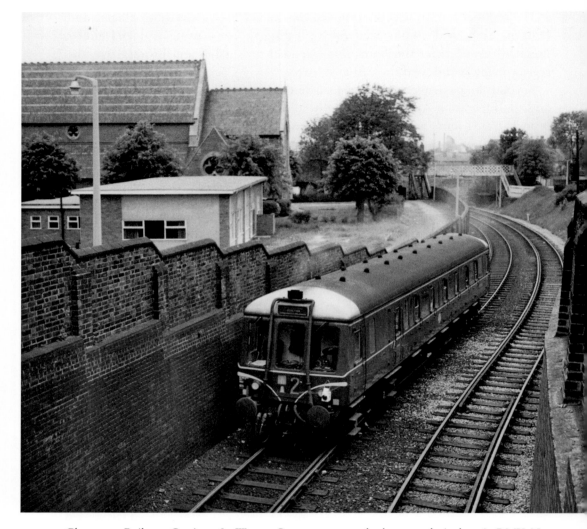

Gloucester Railway Carriage & Wagon Company motor brake second single-unit DMU No. W55006, leaves Stourbridge Town on 11 June 1962 with the 3.40 p.m. to Stourbridge Junction. It carries an oil tail lamp. *Michael Mensing*

First was No. 8 in March 1936, followed by No. 14 and No. 15. Also used were 14XX class 0-4-2Ts, or 64XX 0-6-0PTs, hauling an auto trailer, including *Wren* built by BR in 1951. As the branch had no intermediate station, it was one of the few where passenger trains were allowed to work without a guard. In 1958 BR DMUs arrived. Goods trains were worked by 57XX class 0-6-0PTs. In July 1988 the branch was worked by 'bubble car' Class 122 No. 55033, the only one of its type in Midline livery.

The trial on the branch of a Parry People Mover started in 1996, but various teething troubles were experienced and it only worked intermittently. Problems overcome, Class 139 Nos 139 001 and 139 002 entered full service on 22

June 2009. The 10-ton vehicles powered by propane gas, carried over 20,000 passengers in the first month. As only one Parry People Mover is permitted between the Junction and Town stations, in order to exchange cars, both have to be at the Stourbridge Junction shed and then one run into the goods loop towards a notice prohibiting a Class 139 from passing. This means that if a car fails at Stourbridge Town, the service has to be cancelled.

The line enjoyed an initial train service of seventeen trains each way taking three minutes. By August 1887 the branch had eleven Down and ten Up, no Sunday service being worked. By April 1910 fifty-three trains were run each way on weekdays and seventeen on Sundays. The latter were withdrawn during the First World War and never restored. In July 1922 there were forty-six trains each way, while in July 1938 the service showed sixty-nine Down and sixty-six Up trains. This had decreased to fifty-eight and fifty-two respectively by 1960. The current service is more frequent than ever, with no less than one hundred and seven trains each way appearing in the 2009-2010 timetable, offering a frequency of approximaely a train every ten minutes. Forty-one trains run each way on Sundays. The journey time taken is still three minutes.

The shed at Stourbridge Junction, 6 October 2009, for storing and maintaining the Parry People Movers. *Dr J. L. Batten*

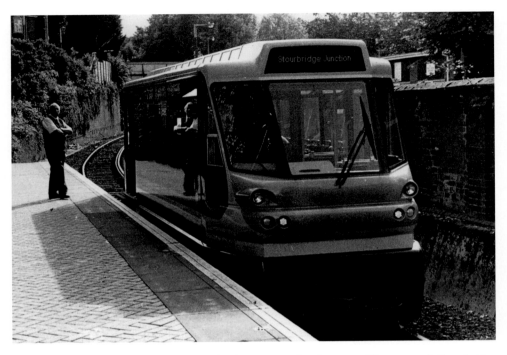

Parry People Mover No. 139 001 at Stourbridge Town, 6 October 2009. View towards Stourbridge Junction. *Author*

The interior of Parry People Mover No. 139 001, 6 October 2009. The conductor is peering into the driver's compartment. *Author*

ALL CHANGE FOR STOURBRIDGE TOWN

WHILE WE BUILD YOUR NEW STATION

JANUARY-APRIL 1994

We are rebuilding Stourbridge Town rail station and extending the bus station to bring you improved facilities.

To complete the job as quickly as possible, we need to temporarily replace the train service between Stourbridge Junction and Town stations with buses.

From 10 January until 22 April buses will run frequently between 06.00 and 23.50 on Monday to Saturday. They will connect with trains at Stourbridge Junction, and are free to rail passengers.

Call the Centro Hotline for further information, or ask for a timetable leaflet.

Buses to Stourbridge Junction leave from Stand E

CENTRO

REGIONAL RAILWAYS ⇥

Poster showing sketch of the new station at Stourbridge Town and details of closure and replacement bus service, 5 February 1994. *Author*

Bibliography

Baker, S. K. *Rail Atlas of Great Britain & Ireland*, Yeovil, OPC, 1996

Beck, K. M. *The West Midland Lines of the GWR* London, Ian Allan, 1983

Biddle, G. and Nock, O. S. *The Railway Heritage of Britain*, London, Michael Joseph, 1983

Bradshaw's Railway Manual, Shareholders' Guide & Directory (various years)

Bradshaw's Railway Guide (various years)

British Railways Pre-Grouping Atlas & Gazeteer, Shepperton, Ian Allan, no date

Boynton, J. *Rails Across the City*, Kidderminster, Mid England Books, 1993

Clark, R. H. & Potts, C. R. *An Historical Survey of Selected Great Western Stations*, Vols
 1-4, Oxford, OPC, 1976-85

Clinker, C. R. *Register of Closed Passenger Stations & Goods Depots*, Weston-super-Mare,
 Avon-Anglia, 1988

Christiansen, R. *The Regional History of the Railways of Great Britain, Vol. 13 Thames &
 Severn*, Newton Abbot, David & Charles, 1981

Cooke, R. A. *Atlas of the Great Western Railway*, Didcot, Wild Swan, 1997

Cooke, R. A. *Track Layout Diagrams of the GWR & BR WR*, Harwell, Author, Section 18,
 1997, Section 31 1978 and Section 33, 1976

Goode, C. T. *The Birmingham & Gloucester Loop*, Hull, Author, 1998

Gough, J. *The Midland Railway, A Chronology*. Mold, RCHS, 1989

Hitches, M. *Worcestershire Railways*, Stroud, Sutton Publishing, 1997

Lyons, E. *An Historical Survey of Great Western Engine Sheds, 1947*, Oxford, OPC, 1974

McDermot, E. T., Clinker, C. R. & Nock, O. S. *History of the Great Western Railway*,
 London, Ian Allan, 1964 and 1967

Midland Railway System Maps, Vol. 4, (The Distance Diagrams),Teignmouth, Peter Kay, no
 date

Midland Railway System Maps Vol. 6 (The Gradient Diagrams), Teignmouth, 1999

Mourton, S. *Steam Routes Around Cheltenham*, Cheltenham, Runpast Publishing, 1993

Robertson, K. *Great Western Railway Halts, Vol. 1*, Pinner, Irwell, 1990

Robertson, K. *Great Western Railway Halts, Vol. 2*, Bishop's Waltham, KRB Publications,
 2002

Shill, R. A. (compiler), *Industrial Locomotives of the West Midlands*, London, Industrial
 Railway Society, 1992

The Branch Lines of
Hampshire

Colin G. Maggs

£16.99
ISBN: 978 1 84868 343 3

ALSO AVAILABLE FROM AMBERLEY PUBLISHING

The Last Days of Steam in
Gloucestershire

Colin G. Maggs

£16.99
ISBN: 978 1 84868 783 7

AVAILABLE FROM ALL GOOD BOOKSHOPS OR ORDER DIRECT
FROM OUR WEBSITE WWW.AMBERLEYBOOKS.COM

ALSO AVAILABLE FROM AMBERLEY PUBLISHING

The Last Days of Steam in
Bristol & Somerset

Colin G. Maggs

£16.99
ISBN: 978 1 84868 340 2